French Riviera and Its Artists

Art, Literature, Love, and Life on the Côte d'Azur

John Baxter

Museyon

New York

Library of Congress Cataloging-in-Publication Data
Baxter, John, 1939-
French Riviera and its artists : art, literature, love, and life on the Côte d'Azur / John Baxter.
pages cm
Summary: "Discover the artists, writers, actors, and politicians who frequented the world's most desired destination during its golden age. In 21 vivid chapters, Baxter presents the iconic figures indelibly linked to the South of France--artist Henri Matisse, who was inspired by the Riviera's color and light; F. Scott Fitzgerald, whose Riviera hosts inspired *Tender Is the Night*; Coco Chanel, whose Saint-Tropez tan became an international fashion trend; and many more. Baxter takes readers into the cars and casinos of Monte Carlo, to the Cannes Film Festival, to the villa where Picasso and Cocteau smoked opium, and to the hotel where Joseph Kennedy had an affair with Marlene Dietrich. Then maps and listings show travelers how these luminaries celebrated life and made art in paradise"-- Provided by publisher.
ISBN 978-1-940842-05-9 (paperback) -- ISBN 1-940842-05-0 (paperback)
1. Arts--France--Riviera. 2. Riviera (France)--Biography. I. Title.
NX549.A3R58345 2015
700.9449'4--dc23
2015004823

Published in the United States and Canada by:
Museyon Inc.
1177 Avenue of the Americas, 5 Fl.
New York, NY 10036

Museyon is a registered trademark.
Visit us online at www.museyon.com
ISBN 978-1-940842-05-9

Printed in China

Cover: The beach in Golfe-Juan, on the Côte d'Azur, August, 1948. Pablo Picasso and Françoise Gilot. Photo by Robert Capa.

"When I realized that each morning I would see this light again, I could not believe my luck."

—Henri Matisse, 1917

French Riviera and Its Artists

TABLE OF CONTENTS

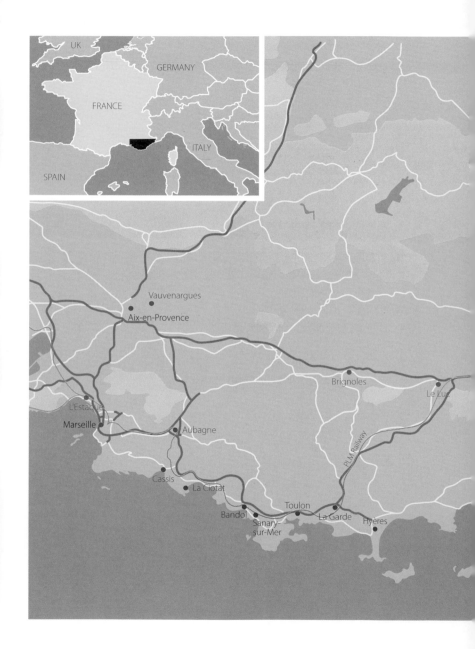

French Riviera

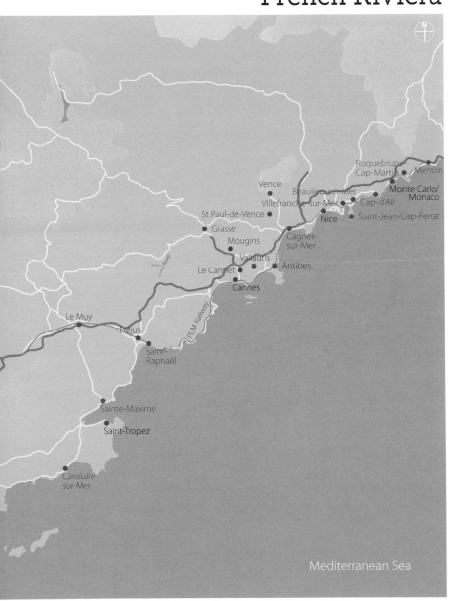

N

Roquebrune-Cap-Martin
Menton
Monte Carlo/Monaco
Vence
Beaulieu-sur-Mer
Villefranche-sur-Mer
Cap-d'Ail
St Paul-de-Vence
Nice
Saint-Jean-Cap-Ferrat
Grasse
Cagnes-sur-Mer
Mougins
Vallauris
Le Cannet
Antibes
Cannes
Le Muy
PLM Railway
Fréjus
Saint-Raphaël
Sainte-Maxime
Saint-Tropez
Cavalaire-sur-Mer

Mediterranean Sea

French Riviera and Its Artists
TIMELINE

Year	Event	Chapter
1856	The first casino in Monaco opens	18
1862	Express trains link Paris to the Riviera by PLM	6
1866	The district of Les Spélugues in Monaco renamed Monte Carlo	18
1869	Founder of the newspaper Le Figaro, Hippolyte de Villemessant, builds Villa du Soleil (Hôtel du Cap)	9
1870	To escape conscription into Napoleon III's army fighting the Prussians, Paul Cézanne takes refuge in L'Estaque	1
1879	The Salle Garnier in Monte Carlo opens	18
1882	Pierre-Auguste Renoir visits Cézanne in L'Estaque	1
1882-1883	Robert Louis Stevenson stays at the Chalet de Solitude in Hyères for sixteen months	4
1887	Guy de Maupassant docks in Menton during a boating holiday	4
1889	Hippolyte de Villemessant reopens the villa as a hotel named Hôtel du Cap	9
1892	Paul Signac buys a house in St. Tropez	16
1895	Auguste and Louis Lumière make their first films in and around La Ciotat, near Marseille	20
1898	Aubrey Beardsley dies at the Cosmopolitan Hotel in March	4
1904	Pierre Bonnard's first visit to the Riviera	11
1905	André Derain paints a study of fishing boats in L'Estaque	1
1906 -1907	Georges Braque and Raoul Dufy share a studio in L'Estaque	1
1908	Renoir moves to Les Collettes outside the village of Cagnes-sur-Mer	2
1910	Ballets Russes relocates to Monte Carlo	8
1912	A stroke leaves Renoir confined to a wheelchair	2
1917	Henri Matisse moves to Nice to avoid the German bombardment of Paris	3
1919	Renoir dies in Cagnes-sur-Mer on December 3	2
1919-1920	Katherine Mansfield lives and works at Villa Isola Bella in Menton	4
1921	Serge Sandberg and Louis Nalpas start The Victorine Studios	20
1921	General Charles de Gaulle spends his honeymoon at Hôtel du Cap	9
1921	Frank Harris retires to Nice with his third wife, Nellie	5
1922	PLM relaunches its first-class-only service to the Côte d'Azur	6
1922-	Harris prints My Life and Loves at his own expense and sells it by mail	5
1923	The Murphys convince the Hôtel du Cap to stay open for the summer	9
1923	Coco Chanel steps ashore at Cannes from the Flying Cloud	7
1924	Alice Terry and Rex Ingram move to Nice	20
1925	Villa Noailles completed	10
1926	William Somerset Maugham buys Villa Mauresque at Cap Ferrat	12
1926	Pierre Bonnard buys Le Bosquet in Le Cannet	11
1927	Isadora Duncan dies in a car accident in Nice	8
1928-1929	Coco Chanel builds La Pausa in Roquebrune-Cap-Martin	7
1929	D. H. Lawrence arrives with wife, Frieda, at the Hôtel Beau Rivage in Bandol	4
1929	Luis Buñuel spends the holidays at Villa Noailles	10
1929	Monaco Grand Prix launches	18
1930	D. H. Lawrence dies on March 2 in Vence	4

THE SKY-BLUE COAST

Beyond the blue horizon
Waits a beautiful day.
Goodbye to things that bore me.
Joy is waiting for me.
Beyond the Blue Horizon. Lyrics by Leo Robin.
Sung by Jeanette MacDonald in *Monte Carlo*.
(1930)

To relax in the sun and open air; to bare one's skin in
the lightest of clothes; to swim near-naked; to dine
on fresh produce amid flowers and within sound
of the sea; to enjoy, in short, all the pleasures of a
temperate climate: this seems so natural we can
scarcely believe that, less than a hundred years ago,
such behavior was regarded as outlandish, even
dangerous.

More surprising still, the people who pioneered the
new lifestyle were not tour operators or hoteliers
but painters, writers and composers. They did so in

the crescent of Mediterranean coastline bounded by the borders of Italy and Spain. The French christened it the *Côte d'Azur*—the sky-blue coast—but to Anglophones it will always be the French Riviera.

Nineteenth-century European culture, both physically and intellectually, took place almost entirely indoors. Preoccupied with the life of the mind, most intellectuals avoided the outdoors, leaving the natural world to a relatively small community of biologists and taxonomists.

Novelists wrote of cities and city people. Poets, painters and sculptors depicted incidents from legend and the past. At the annual Paris group art exhibitions, known as salons, "history paintings" of great battles, scenes from the Bible or the myths of Greece and Rome were exhibited at eye level, the place of honor, since the true function of art was believed to be education and moral improvement. Portraits lacking inspirational qualities were allocated the next level, while anything regarded as simply "pretty pictures"—landscapes or still lifes—was exiled to the third level, up near the ceiling.

Art aspired to the ideal of the time, where flesh was always alabaster white and suntanned skin signified someone inferior, a laborer or peasant, forced to work outdoors. To achieve the desirable pallor, artists worked in studios with windows that admitted a carefully regulated light. Morning sunshine was too harsh and that of evening tainted with the hues of sunset. Only one direction offered

the pale, uniform illumination regarded as perfect, so the best studios always faced north.

The distinction of being the first artist to explore the light and color of the south belongs to Paul Cézanne. As early as 1878, he depicted the red earth, deep blue skies and luxuriant vegetation of Provençe. He had an advantage, however. Born in Aix-en-Provençe, he grew up with that light and culture in his bones.

The next painters to travel south were seeking both new light and new subjects. Influenced by philosopher Jean-Jacques Rousseau, they believed rural life more noble and "natural" than that of the city. Vincent van Gogh and Paul Gauguin pioneered the migration. In the autumn of 1888, they lived and worked for eight weeks in the Provençal town of Arles. From the start, they rejected any sense of elitism. Their later-famous *Yellow House* would be, van Gogh insisted, "an artists' house, but *not affected*; on the contrary, nothing affected."

Henri Matisse followed in 1904, Pierre-Auguste Renoir in 1907, and Picasso not until 1919. The harsh light and luxuriant colors of the Mediterranean were not to every artist's taste, however. Georges Braque painted around L'Estaque, near Marseille, during 1908, but his mind was already on Cubism, with its grey/brown metropolitan palette and preoccupation with precision and form.

Others found nothing on the Riviera to inspire them but enjoyed the climate. Chaim Soutine painted

mainly in Paris and the north. However, in 1918, his dealer Léopold Zborowski took him to the Riviera to escape the German bombardment of Paris. When, in 1923, American collector Albert Barnes bought sixty of Soutine's paintings, the artist grabbed the money, ran out into Montparnasse's rue Delambre, hailed a taxi, and ordered it to drive him to Nice, 400 miles away.

"At that time, no one went anywhere near the Riviera in summer. The English and the Germans who came down for the short spring season closed their villas as soon as it started to get warm in May. None of them ever went in the water, you see, " said Gerald Murphy, of the Riviera in the early 1920s.

Although painters were the first to celebrate the Riviera, the leisured rich made it famous. In 1834, Lord Henry Peter Brougham, Britain's Lord Chancellor, on his way to Italy, was halted at the River Var by a cholera epidemic on the other side. During his enforced delay, he fell in love with, as he wrote, "the delightful climate of Provençe, its clear skies and refreshing breezes, while the deep blue of the Mediterranean stretched before us. The orange groves perfumed the air while the forest behind, ending in the Alps, protected us from the cold winds of the north." He built a villa there, and urged friends to do the same.

During the last half of the nineteenth century, Cannes became the winter refuge of the aristocracy of the Balkans and particularly Russia. They arrived as their rivers froze in November and

only returned when they thawed in May. Although railways and roads gradually linked the main towns, the rich traditionally came on private yachts. Once ashore, few traveled inland more than the distance of a walk. It was the Mediterranean they were there to admire. Villas and hotels looked out to sea, and esplanades along the seafront provided a place for visitors to stroll, "taking the air." When a particularly harsh winter blighted the citrus crop in 1822, British charities hired the unemployed fruit pickers to build a plaza along the seafront at Nice. It became known as the Promenade des Anglais—the promenade of the English.

Before World War I, ships of the Russian fleet periodically cruised the Mediterranean, a warning to the increasingly militaristic German states. They docked at Villefranche, Cannes and in particular Nice. Once members of the Russian imperial family took to wintering there, a permanent colony developed, complete with an Orthodox church, built with the patronage of the empress and opened in December 1859. After the empress dowager Maria Feodorovna settled in Cap d'Ail in 1896, she decreed the construction of a cathedral on boulevard du Tzarewitch. The Tsar Nicholas II consecrated it on December 18, 1912. In 1870, 170 Russians owned property in Nice. By 1914, the number had risen to 600.

Nobility became the norm along the Riviera. Guy de Maupassant, on a sailing holiday in 1888, joked about the prevalence of crowned heads. "Princes, princes, everywhere princes! Those who love princes are indeed happy. No sooner had I set foot yesterday

morning on the promenade of the Croisette than I met three, one after the other. In our democratic country, Cannes has become a city of titles."

The relaxed nature of Riviera life helped humanize the aristocracy. Some kept a guest book in their holiday homes, which one could sign, although footmen by the door ensured that only the "right sort" of people got that far. Kings and princes took an evening stroll with their families, much the same as commoners. They could even, unceremoniously, bump into one another. In her journal for April 4, 1898, Queen Victoria wrote "On our way down to Villefranche we met Leopold II of Belgium walking. He had arrived in Villefranche harbour on his yacht this morning." On her death bed in 1901 on the chilly Isle of Wight, Victoria is supposed to have said, "If only I were in Nice, I would get better."

Victoria visited the Riviera eight times—no match for Leopold, who was her first cousin. He owned a house on Cap Ferrat, with another for his mistress, a third for his personal priest, and a private zoo as well. Victoria's son, the notoriously dissolute Prince of Wales and future Edward VII, felt more at home in Cannes and Monte Carlo than in London, and more free to indulge himself. "I go to the Riviera as I would a club," he said. "It's a place with good company where everyone mingles, just like a garden party." When Oscar Wilde fled to France in 1898 after being jailed for his homosexual activities, he encountered the Prince in the street in Cannes. Raising his hat, Wilde was not surprised when the gesture was ignored. However, the Prince

had simply not recognized him. Once he did, he hurried after Wilde, and shook his hand—a gesture unthinkable in London.

> *The Terrace of a Hotel in France.*
> *Amanda: (looking out over the harbor.) Whose yacht is that?*
> *Elyot: The Duke of Westminster's I expect. It always is."*
> —Noël Coward, *Private Lives* (1930)

Asked why, in 1980, he chose to write *The Name of the Rose*, a detective story set in the fourteenth century, Italian cultural critic Umberto Eco explained "A man of my age has two choices—to write a novel or run off to the south of France with a chorus girl. I chose the novel..." He smiled "...though I still reserve the right to run off one day with a chorus girl."

Many writers spent time on the Riviera—with or without a chorus girl. In his novel *The Rock Pool*, published in 1936, the British author and critic Cyril Connolly joked about the tendency of such best-selling authors as Aldous Huxley, Edith Wharton, Michael Arlen and E. Phillips Oppenheim to migrate south. "All along the coast from Huxley Point and Castle Wharton to Cape Maugham, little colonies of angry giants had settled themselves: there were Campbell in Martigues, Aldington in Le Lavandou, anyone who could hold a pen in St. Tropez, Arlen in Cannes, and, beyond, Monte Carlo and the Oppenheim country."

Much as they enjoyed the lifestyle, however, few of these exiles wrote about it. The landscape and climate was more conducive to painting than literature. As painters worked in the open, the Mediterranean light made them reach automatically for their brushes and palette. Writers, creatures of the shade, more often reached for a glass or a girl, and closed their eyes. In Robert Sherwood's play *The Petrified Forest*, an unsuccessful novelist described the lassitude that reduced many writers to inactivity.

"I married a lady of wealth. She was very liberal to me. She saw in me a major artist, profound but inarticulate. She thought that all I needed was background, so she proceeded to give it to me—with southern exposure and a fine view of the Mediterranean. For eight years I reclined there on the Riviera, on my background. I waited for the major artist to emerge and say something of enduring importance. But he preferred to remain inarticulate."

Most writers who, like Eco, fantasized about life on the Mediterranean were content to let it remain a dream. Even those who spent time there seldom lingered. British novelist J. G. Ballard was typical. He vacationed in France or Spain every year and even set two of his novels there, including the 2000 *Super-Cannes*, which takes place in the technology park of Sophia-Antipolis, France's Silicon Valley, that occupies the hills behind Antibes and Nice. "I would move there tomorrow if I could afford it," Ballard said of the South of France. But as he was worth more than four million pounds at the time,

lack of money was not his true reason for returning to suburban London.

In truth, he shared a suspicion of continental Europe endemic among many Britons. Novelist Kingsley Amis summed up in a single word all that seemed alien or malign about such countries: he called them "abroad." Ironically, his 1954 novel *Lucky Jim* won the award given by British writer (and Riviera resident) William Somerset Maugham to a promising writer under thirty-five, with the proviso that it be spent on foreign travel. Amis chose to visit Portugal, where ignorance of the language, an unfamiliarity with local customs, and the distracting presence of wife and children contributed to the detestation of "abroad" expressed in his 1958 novel *I Like It Here*.

All the same, between the wars nobody was more eager than the Anglo-Saxons to visit the Riviera— nor more anxious to keep it at arm's length. Few visitors spoke French. Guidebooks even discouraged it. Anyone who spoke their language, ate their food, indulged in their pastimes or became sexually involved with them was regarded as having "gone native," and shunned accordingly.

Much as they did at home, the rich played polo, the middle class golf, while the few workingclass visitors watched football or attended horse races at La Napoule. Occasionally, the classes came together to watch what were thought of as authentic local activities, in particular the Battles of Flowers.

According to a 1925 British travel guide, "the Battles of Flowers are amongst the most appreciated of the Riviera amusements, and are particularly brilliant in Cannes; they take place on the Esplanade des Alliés, with the magnificent bay of Cannes as a back ground." Mostly the "battle" consisted of a parade of flower-decorated floats from which locals pelted the crowd with blooms. Originally part of the carnival that celebrated the end of Lent, these battles proved so popular that they were staged regularly in Cannes, Nice and Villefranche between February and May, long after they had ceased to have any religious significance.

No festival, however colorful, would keep an English lady or gentleman on the Riviera past the end of May, since early June marked the beginning of the London "season," which didn't end until August 12—the "Glorious Twelfth"—that marked the opening of the grouse shooting season. In between came the races at Ascot, the Henley Regatta, cricket at Lord's, the Wimbledon tennis championships, and numerous debutante balls, absence from any of which would be a social disaster no fashionable person dared contemplate.

> *Mad dogs and Englishmen go out in the mid-day sun.*
> —Noël Coward

After the 1917 revolution, the Riviera's Russian colony increased as exiled aristocrats and military men fled to the region where they had been happiest. By 1919, 1,892 Russians lived in the area

of Alpes Maritimes, a figure that rose to 2,000 in 1923 and 5,312 in 1930. Some worked as doormen, chauffeurs and waiters in hotels and restaurants where they had once been clients. Still others relied on charity doled out by the few who had money in French banks or were shrewd enough to spirit it out of Russia ahead of the Bolsheviks.

British and American navy ships replaced Russian vessels in the harbors of Nice and Villefranche. With the French franc devalued by the war, American tourists could afford to stay at the Carlton in Cannes and the Negresco in Nice. Others bought or leased villas left empty by the Russians. The new arrivals gambled, danced, dined and, above all, got drunk, because, unlike the United States under Prohibition, alcohol in France was plentiful, cheap and legal.

Like the Russians, the Americans and British remained birds of passage, partying through the winter but returning home in the spring. To do otherwise was regarded as foolhardy. *How To Be Happy on the Riviera*, published in London in 1927, reminded visitors that "the season begins on November 15 and ends on May 15," and warned them to wear a coat and scarf even on sunny days. By mid-May, all prudent Britons were headed home, or to one of the cooler resorts of the Channel coast, such as Deauville.

Life on the Riviera began to change in 1924, when the French railways relaunched and rebranded their overnight, first-class-only service to the Mediterranean. As *Le Train Bleu*—The Blue Train, it

collected tourists off the channel ferry and carried them to Cannes, Nice, Antibes, Monaco and Menton. By the early 1930s, the annual May retreat north had slowed. In *Tender Is the Night*, published in 1934, F. Scott Fitzgerald wrote of the Riviera that "lately it has become a summer resort of notable and fashionable people; a decade ago it was almost deserted after the English clientele went north in April."

Cole and Linda Porter astonished their friends when they rented the Chateau de la Garoupe in Antibes during the summers of 1921 and 1922. "We enjoyed every moment," Cole wrote, "but we were considered crazy. It was before the days when anyone went to the Riviera in the summer, as the weather was considered too hot." Yet the Porters never swam. When Gerald Murphy, a gifted painter but reluctant heir to the Mark Cross leather-goods empire, visited them, he and his wife Sara found the nearby beach so little used that dried seaweed covered the sand three feet deep.

At the tip of the Cap d'Antibes, the rundown Hôtel du Cap, like most hotels at the time, closed in May and reopened in October. In return for it agreeing to remain open through the summer of 1923, the Murphys leased an entire wing while they looked for a house to buy. Eventually they built their own, named it Villa America, and invited artists and writers to sample an outdoor lifestyle that stressed swimming and sunbathing.

Travel historian Eric Newby credits the Murphys with transforming the Riviera. "Without realizing it,

they had invented a new way of life and the clothes to go with it. Shorts made of white duck, horizontally striped matelots' jerseys and white work caps bought from sailors' slop shops became a uniform. From now on, the rich, and ultimately everyone else in the northern hemisphere, wanted unlimited sun, the sea, sandy beaches or rocks to dive into it from, and the opportunity to eat *al fresco*." Another writer called this life "the new paganism."

One author alone betrayed any disquiet about the surrender of the American expatriates to a landscape that had devoured every culture that tried to establish a foothold on its rocky shore. In her only novel, *Save Me the Waltz*, F. Scott Fitzgerald's wife, Zelda, cast the ominous shadow of history over the sunlit Côte d'Azur.

"The deep Greek of the Mediterranean licked its chops over the edges of our febrile civilization. Keeps crumbled on the grey hillsides and sowed the dust of their battlements beneath the olives and the cactus. Ancient moats slept bound in tangled honeysuckle; fragile poppies bled the causeways; vineyards caught on the jagged rocks like bits of worn carpet. The baritone of tired medieval bells proclaimed disinterestedly a holiday from time. Lavender bloomed silently over the rocks. It was hard to see in the vibrancy of the sun."

Her voice, however, was in the minority, and soon muffled by the whirr of cicadas, the ripple of waves, and the lassitude of a lifestyle predicated on physical content.

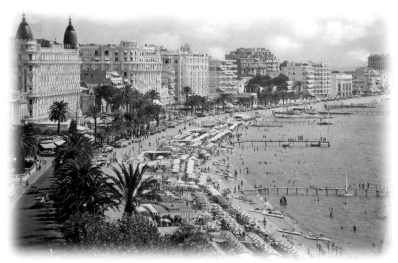

La Croisette: hotels, beach and bathing huts in Cannes, photo by Jean Gilletta

OF TIME AND LIGHT: The Rational Eye of Paul Cézanne

Superficially, neither Paul Cézanne himself—dour, black-bearded, reclusive, and often rude, shy, angry or depressed—nor his expressionless portraits and meticulously assembled landscapes, subdued, precise but empty of people, had much in common with the sunny and hedonistic Riviera. Reflecting this, the brief time he spent there was at L'Estaque, the same semi-industrial town near Marseille where Georges Braque, no more cheerful than Cézanne, would later attempt, with little success, to contain the colors and light of the Mediterranean within the chilly mathematics of Cubism.

And yet it is Cézanne to whom almost every later artist of the Riviera paid tribute as "the father of us all." Where Impressionism had freed the

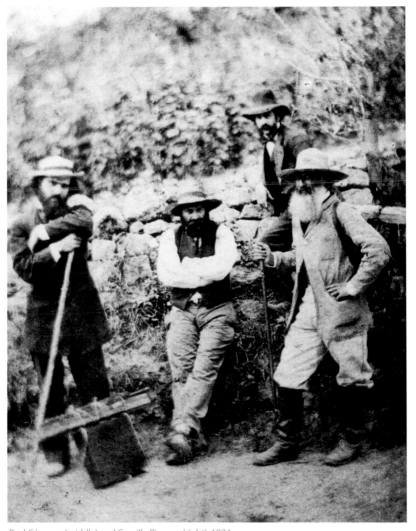

Paul Cézanne (middle) and Camille Pissarro (right), 1874

painter's brush, making it a tool of the imagination, responsive to the spirit of the moment, Cézanne demanded that the artist suppress this spontaneity. His own best example, he would spend hours contemplating an apparently simple rock or tree before committing a single brushstroke to canvas.

Inspired by such old masters as Peter Paul Rubens, he studied each subject until he understood its topological form. Looked at analytically, a tree was essentially a cylinder, an apple or a human head both spheres, a range of hills no more than an arrangement of pyramids and cones. To Cézanne, a devout Catholic, this underlying unity proved the existence of a divine order in nature. "When I judge art," he wrote, "I take my painting and put it next to a God-made object like a tree or flower. If it clashes, it is not art."

Although Cézanne never lacked for money from his prosperous family in provincial Aix-en-Provençe, he received little encouragement from them in either his personal life or his art. He studied law at the insistence of his father, who expected him to enter his bank. Preferring to draw, Cézanne took art classes in Aix, left for Paris, failed there, returned, worked briefly in the bank, but again gravitated to the capital, encouraged by a school friend, Émile Zola, soon to be famous as a novelist.

For Cézanne, living away from his hometown proved as hard as remaining. "When I was in Aix," he wrote from Paris, "it seemed to me that I would be better elsewhere, but now that I am here, I miss Aix. When

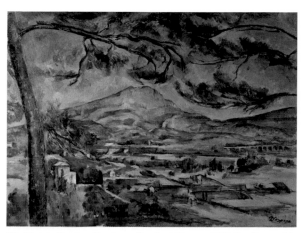

Mont Sainte-Victoire with a Large Pine, Paul Cézanne,1887, The Courtauld
Institute of Art

one is born there, he is ruined; nothing else means
anything to you." In Paris, he was nostalgic for the
craggy landscape around Aix and the often harsh
but always revealing Provençal light. In particular,
he missed Mont Sainte-Victoire, the mountain that
reared out of the landscape a few miles from Aix.
Its uncompromisingly pyramidal form confirmed
his theories about the volumetric basis of nature.
Once he returned, he constructed a rough studio
in an ancient stone quarry on the edge of Aix from
which he had an unimpeded view of this monolith.
He painted it forty-four times in oils and forty-three
times in watercolor.

Rejected repeatedly for the annual Paris salon,
Cézanne suffered a sustained mauling from critics,
one of whom suggested that a portrait was so
horrible it might induce miscarriages in pregnant

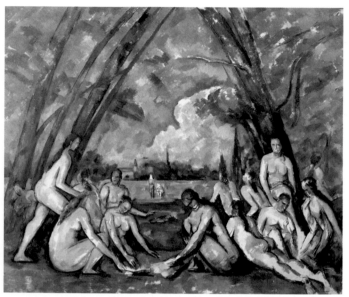

The Large Bathers, Paul Cézanne, 1900-1906, Philadelphia Museum of Art

women. Never comfortable painting people, he seldom worked with live models. His best-known attempt at figure painting, a nude group known as *Les Grandes Baigneuses*—the Large Bathers— was based on sketches made as a student or from Renaissance paintings in the Louvre. The subject occupied him in various forms for years. With each new version, the women and the arrangement of their bodies became more stylized. He died with the picture unfinished, but already halfway to abstraction.

In 1870, to escape conscription into Napoleon III's army fighting the Prussians, Cézanne took refuge

in L'Estaque, a town on the Gulf of Marseilles where he had spent holidays as a boy. Seen through the mature eyes of an artist, the Mediterranean landscape was a revelation. For the rest of his life he would return there, often staying at a house on Place Malterre and painting views of the town and the sea beyond from a nearby headland. In 1876, he described the town to friend and fellow artist Camille Pissarro as "like a playing card. Red roofs over the blue sea. The sun here is so terrific that objects appear silhouetted not only in white or black, but in blue, red, brown, violet."

In January 1882, Pierre-Auguste Renoir visited him en route to Paris from Italy. "What a beautiful place this is!" Renoir wrote. "It must surely be the most beautiful place in the world." During his few days there, Renoir finished four canvases, mostly studies of the dappled light on paths in the heavily wooded hillsides, a subject that didn't interest Cézanne. On one day, however, the two men set up their easels on his favorite point above the town to paint the same scene. The result are Renoir's *Rocky Crags at L'Estaque* and Cezanne's *The Viaduct at L'Estaque*.

The contrast between their visions is striking. Renoir's painting demonstrates his preference for gentle landscapes, with rolling hills and curved shapes, while Cézanne's *Viaduct* depicts a more intense, angular interpretation of the same scene. While Renoir's understanding of what he sees is lush and soft, Cezanne's layers of planes and silhouettes are more austere, flat, sculptural, and ultimately more modern. Renoir seeks to soften

the view, but Cézanne reminds us of geometry's relentless logic.

Many critics, while recognizing Cézanne's technical mastery, found his canvases unpleasant, even ugly. "Cézanne never was able to create what can be called a picture," wrote anti-modernist Camille Mauclair. Others remarked uneasily that one had to distinguish between Cézanne's worthwhile ideas and the often jarring use he made of them.

In 1895, Cézanne had the good fortune to meet the young dealer Ambroise Vollard, who had just opened a small gallery in Paris. Their rapport was instantaneous. Vollard compared the impact of his paintings to a punch in the stomach. "An innovator like Cézanne was considered a madman or an impostor," he said, "and even the avant-garde regarded him with contempt. On the spot, I managed to buy 150 canvases from him, almost his entire output. I raised a great deal of money— my entire fortune went into it. And I anxiously wondered whether my audacity might not turn out to be the ruin of me. I didn't even have enough money left over to frame the canvases decently."

The show, a huge success, established not only Cézanne's reputation but that of Vollard. It also reassured those who admired Cézanne that they were on the right track. Pissarro wrote to his son, "I believe this dealer is the one we have been seeking. He likes only our school of painting or works by artists whose talents have developed along similar lines. He is very enthusiastic and knows his job."

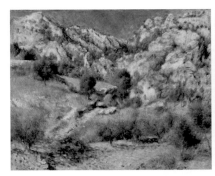

Left: *Rocky Crags at L'Estaque*, Pierre-Auguste Renoir, 1882, Museum of Fine Arts Boston;
Right: *The Viaduct at L'Estaque*, Paul Cézanne, 1882, Allen Memorial Art Museum

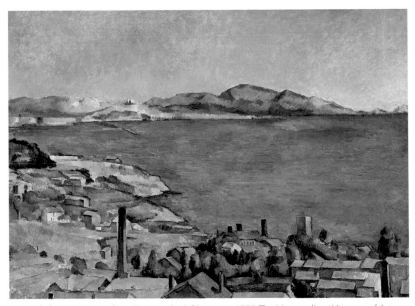

The Gulf of Marseilles Seen from L'Estaque, Paul Cézanne, c. 1885, The Metropolitan Museum of Art

Paul Cézanne, 1906, photo by Gertrude Osthaus

Cézanne died in 1906 of pneumonia after being caught outside in a rainstorm. So modern do his pictures appear today that one easily forgets they were done at a time when most artists were still preoccupied with Impressionism.

His influence would prove to be far wider than anyone envisaged, not only on painting but on theories of art, and also on literature. Gertrude Stein admired his work, and urged Ernest Hemingway to study the way in which he concentrated on his immediate subject, to the exclusion of all else. Hemingway spent hours in Paris's Musée du Luxembourg, where, prior to the construction of the Musée d'Orsay, the Cézannes of the national

collection were displayed. "Cézanne is my painter, after the early painters," he said. "I can make a landscape like Mr. Paul Cézanne, I learned how by walking through the Luxembourg Museum a thousand times."

Epilogue

The house in L'Estaque next to the church on the Place Malterre where Cézanne frequently lived and worked is marked today with a plaque. L'Estaque inspired many other artists. In 1905, André Derain painted a study of fishing boats. Georges Braque went there in the winter of 1906 and 1907, just after Cézanne's death. The following year, he and Raoul Dufy shared a studio in the town, and, with Othon Friesz, painted a number of Cubist-influenced images of the town and surrounding countryside. Less well known, locally-born artist Adolphe Monticelli is honored by a museum in a fort overlooking the gulf of Marseilles.

Aix-en-Provence has a number of Cézanne sites, including the studio created for him by his father in the family mansion and the hut that he set up in the nearby stone quarries from which he so often painted Mont Sainte-Victoire.

PIERRE-AUGUSTE RENOIR: Naked Among the Olives

So closely is Pierre-Auguste Renoir associated with Impressionist scenes of bohemian Montmartre, of dancers in *bals musettes* and picnics along the Seine, that one forgets he spent eleven equally productive years—his last—on the Riviera.

Beginning in 1892, rheumatoid arthritis relentlessly reduced Renoir's ability to paint. An arm broken in an 1897 bicycle accident led to progressive rigidity in his shoulders and hands. The sight in his left eye also deteriorated. In 1907, then sixty-six, and hoping Mediterranean warmth would restore some movement to his joints and bright sunlight compensate for failing vision, he bought

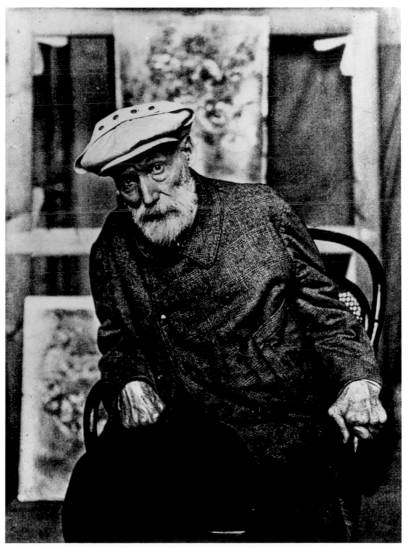

Pierre-Auguste Renoir at his home Les Collettes at Cagnes, 1915

Les Collettes, outside the village of Cagnes-sur-Mer

Les Collettes, a ten-acre farm outside the village of Cagnes-sur-Mer, on the hills above Nice.

No stranger to the south, Renoir had travelled in Italy as a young man and also visited North Africa. In January 1882, he called on Cézanne in L'Estaque, and drew new inspiration from the sparseness and precision of his work, in particular his decision to concentrate on essential forms, to "treat nature by the cylinder, the sphere, the cone."

"I had gone as far as I could with Impressionism," wrote Renoir, "and I realized I could neither paint nor draw." Studying Raphael and Titian in Italy led him to a new appreciation of Classicism. No longer interested in recording a passing impression of life, he concentrated instead on the volumes, tones and textures of nature and the body—not the real but the ideal.

Aggressive representation by his dealer Ambroise Vollard ensured that his paintings continued to sell at high prices. In particular, American inventor Albert C. Barnes amassed the world's largest

collection of his work, an astonishing 181 items.

With such patronage, Renoir could afford every
material comfort in his new Riviera home.
Supervised by his wife Aline, his former model,
twenty-three years his junior, the farmhouse was
extended and enlarged and the gardens landscaped
to show off the lemon groves and massive olive
trees. She installed a glassed-walled studio and
every modern convenience. Unusual for the time,
Les Collettes had electricity, central heating, and
a telephone. Renoir also owned an automobile. In
1908, he and Aline moved in with their three sons.

Age and infirmity reduced but didn't eradicate
Renoir's libido. If anything, being imprisoned in a
deteriorating body sharpened his appreciation of
women. As the new house required many servants,
he surrounded himself with pretty girls, some of
whom became his models. He celebrated their
voluptuousness in such late paintings as *Les
Baigneuses* (The Bathers, 1918-1919) in which plump
nudes romp and lounge like figures out of Rubens.

Some people found these overweight and highly-
colored figures close to self-parody. American
painter Mary Cassatt sneered in 1913 at his
"enormously fat red women with very small heads."
Renoir was unapologetic. The young women
who sang and chattered as they went about their
household chores were his muses. He needed their
company, their admiration, their sexuality—but not,
however, their intelligence. He believed education
robbed a woman of the simplicity and natural charm

that made her interesting. Exaggerating their bodies at the expense of their heads placed the emphasis where he felt it belonged.

The Riviera climate stimulated Renoir's senses and brightened the colors of his palette but only marginally improved his health. A stroke in 1912 left him confined to a wheelchair. As arthritis further invaded his joints, he could only grip a brush if an assistant placed it in his fingers, which were often bandaged to prevent his nails from digging into his palms. He worked on a vertical roll of canvas, leaving the cutting, stretching and framing to helpers.

Following his stroke, a doctor from Vienna spent a month at the farm in hopes of getting him back on his feet. With diet and exercise, Renoir was able finally, with the help of friends, to take a few steps, only to slump, exhausted, into his chair. "I give up," he sighed. "The effort takes all my willpower. I'd have nothing left for painting. If I have to choose between walking and painting, I'd rather paint."

Initially Renoir spent only winters in Cagnes, returning in summer to Paris, but his stroke and the outbreak of war in 1914 imprisoned him on the Riviera. The war affected him deeply. His two eldest sons were wounded. Jean, later a noted film director, was hospitalized in eastern France. In 1915, Aline crossed the country to visit him, but died unexpectedly soon after her return.

Renoir took refuge in his work. When Vollard, looking for ways around his infirmity, suggested

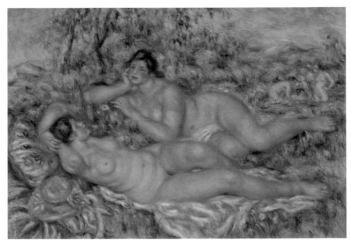

The Bathers, Pierre-Auguste Renoir, 1918-1919, Musée d'Orsay

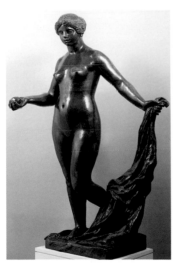

Venus Victorious, 1914

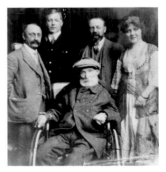

Renoir surrounded by Albert Marquet, Walther Halvorsen, Henri Matisse and Andrée Heuschling, 1918

sculpture, the painter held up twisted fingers and said "Find me a pair of hands!" Through Aristide Maillol, noted for his statues of female nudes, Renoir met Richard Guino, a gifted young Catalan sculptor, who moved into the house at Cagnes.

A succession of sculptures followed, typified by the larger-than-life *Venus Victorious*, showing the goddess of love holding the golden apple she has just awarded to Paris. (A copy of this figure stands in the grounds of Les Collettes.) Most of the new figures were based on earlier paintings by Renoir, which Guino remodeled in three dimensions.

A dispute with Guino marred Renoir's last years. Although Vollard promised Guino that the collaboration would make him rich, the bronzes they created together were sold as Renoir's work alone. The family were adamant that Renoir supervised each figure, using a baton to indicate where clay should be added or removed, but Guino claimed they were almost entirely his work, and that Renoir just scratched his signature in the clay before the figures went for casting.

Guino was particularly offended that when the great sculptor Auguste Rodin visited Renoir, he was given the day off. Returning to the studio, Guino found that someone had disarranged the cloths draped over the clay figures to keep them moist. He accused Renoir of showing them to Rodin as his work alone. The two men parted on bad terms. After leaving Cagnes, Guino did little of note, and descended into depression.

In 1919, Renoir traveled to Paris to see some of his work hung in the Louvre—the first living artist to be so honored. He died in Cagnes-sur-Mer on December 3, 1919 but is buried next to his wife in her hometown of Fayolles in the Dordogne. Few men battled more stubbornly with physical infirmity to achieve their vision. As he told his old friend Matisse, "Pain passes, but beauty endures."

Epilogue

Renoir's Riviera work suffered a critical eclipse after his death, although this was by no means universal. The two men never met, but Picasso admired the late paintings more than Renoir's Impressionist canvases, and owned a number of them.

Les Collettes, acquired by the town of Cagnes-sur-Mer, is maintained as a museum of exceptional charm and tranquility. The house contains a small collection of paintings and sculptures as well as numerous personal items, including much of the original furniture, and many letters, documents and photographs. There is a recreation of Renoir's atelier, and a display of the sculptures created in collaboration with Richard Guino. In 1973, Guino's heirs won a lawsuit against the Renoir estate, and were awarded half the sale price of the statues the two artists had created.

Once he became a film director, Jean Renoir returned occasionally to film Provence. The drama *Toni* (1935), an early work of Neo-Realism, was set among the immigrant Italian farm workers of the region. In 1959, he used Les Collettes to shoot part of *Le Dejéuner sur l'herbe–Lunch on the Grass*. A fable with overtones of his father's life there, it describes a politician, Etienne Alexis, who's determined to replace physical sex with artificial insemination. During a picnic, a mysterious shepherd with a set of Pan pipes casts a spell over the company, and Alexis finds himself having old-fashioned intercourse with Nénette, the sensual peasant girl who cares for the guinea pigs in his laboratory.

HENRI MATISSE: The Brush and the Blades

Asked at the end of his life "Why have you never been bored?" Henri-Emile-Benoit Matisse replied "For more than fifty years I have never ceased to work. Work cures everything."

His creativity triumphed over age and illness. When he was no longer able to stand upright to paint a mural, he attached charcoal to a long stick and sketched out the design on the wall for others to fill in. Unable to walk, he worked from a wheelchair. Finally confined to bed, he continued to create, cutting shapes from colored paper.

Matisse spanned an era. The year of his birth, 1869, coincided with the completion of the railroads joining the east and west coasts of the United States.

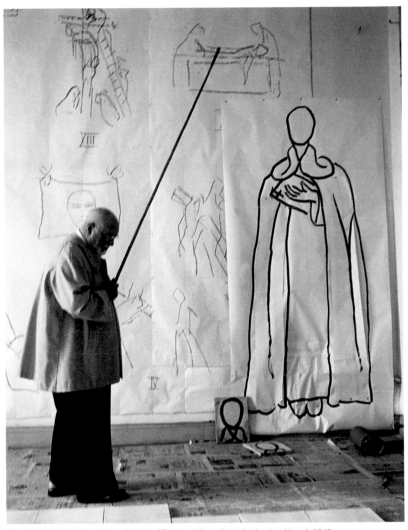

Henri Matisse in his studio at the Hôtel Regina, Nice, photo by Lucien Hervé, 1949

In 1954, the year he died, the first hydrogen bomb detonated at Bikini Atoll. "He lived through some of the most traumatic political events in recorded history," said art critic Robert Hughes, "the worst wars, the greatest slaughters, the most demented rivalries of ideology, without, it seems, turning a hair."

This isn't entirely true. During the Nazi occupation of France, friends and family members of Matisse were tortured and killed. U.S. Air Force bombing of Nice in 1944 forced him to move to the hillside town of Vence. But no hint of anguish appears in his work, which remained tranquil and life-affirming. His concentration was unswerving. Neither politics nor the feuds and cliques of the art world interested him. He signed no manifestos, embraced no radical agendas. The most he hoped for his painting, he said, was that we should enjoy it as a tired man might settle into a favorite armchair.

Though few artists have been so prolific, Matisse's first twenty years were inauspicious. His father, a grain and hardware merchant in the northern city of Saint Quentin, forced him to study law in Paris. He returned home to practice, but his heart wasn't in it. Plagued by anxiety and a convenient attack of appendicitis, he began painting as therapy and never looked back.

As a hot new talent and a member of the clique known as *Les Fauves* or Wild Beasts, he was taken up by Gertrude Stein. She collected so many of his canvases that he frequently brought prospective

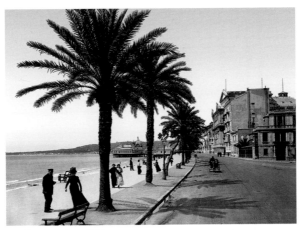
Nice Promenade, c. 1900

clients to her apartment on rue de Fleurus to view
them. Stein acquiesced, providing they came after
she had finished the week's work—the beginning, it's
thought, of her famous Saturday evening soireés.

In 1917, Matisse left Paris, then being bombarded by
German artillery and aircraft, and moved to the
tranquility of Nice. After staying initially in the
Hôtel Beau Rivage, earlier guests of which included
Friedrich Nietzsche and Anton Chekhov, he moved
to a villa on Mont Boron, the Hôtel Méditerranée,
then to a building at 1 Place Charles Félix where he
kept an apartment from 1921 to 1938. That year, he
moved to the Hôtel Regina, in the hilltop village of
Cimiez. The cool high-ceilinged room with white
tiled interiors to minimize the heat was surrounded
on one side by a park filled with ancient olive trees
and on the other by the remains of Roman baths,
beyond which the Mediterranean was distantly

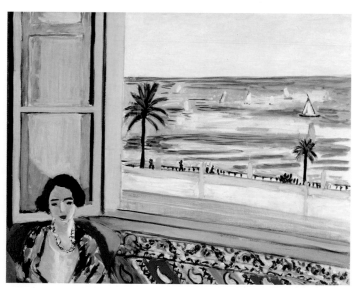

Seated Woman, Back Turned to the Open Window, Henri Matisse, c. 1922, Montreal Museum of Fine Arts

Henri Matisse drawing the model Zita as odalisque, 1928

visible. There, with the company of his beloved schnauzer Raoudi, Matisse was free to explore the possibilities of this largely untouched environment.

The light and color of the Côte d'Azur induced a remarkable quantity and variety of work. To most painters, the Riviera was one subject among many. Matisse made it his preoccupation. Inspired initially by Cézanne, he widened and deepened that artist's appreciation of the Provençal climate. In particular he was devoured by color. Nobody painted more vivid blues than Matisse, more earthy ochres, or a more luxuriant green. Many canvases show a garden and the distant sea through an open window, but he was just as ready to use these hues in a portrait— often to the dissatisfaction of his sitters, who protested at being given yellow or brown complexions.

Among the first artists to look across the Mediterranean to North Africa, Matisse incorporated the colors and textures of Morocco and Tunisia into his work. His seminude reclining harem girls alerted the French to an African eroticism which, until then, most ignored. "Why should we visit Africa?" asked Picasso in admiration. "We have it already in Matisse's *odalisques*."

As long as his health held out, Matisse travelled. Like the painter Paul Signac at St. Tropez, he enjoyed boating, and was active as a canoeist, winning many awards. The Club Nautique de Nice honored him for the sheer number of expeditions—154 voyages in six months. In 1930, he

visited Tahiti, returning with vivid impressions of jungle vegetation and gaudily colored tropical fish, which would find expression four decades later in the cut-out paper shapes of his final creative burst.

His secondary interest after water sports and the light and landscape of the Riviera was women. His distinctive pen and ink portraits of sharp-featured girls with mops of curls were among the most frequently reproduced images of the period. He was less gifted in sculpture. Those statues that survive, almost all of women, are closer to the clay "sketches" of Auguste Rodin than to the more finished work of such contemporaries as Aristide Maillol. However, one senses in them his almost erotic pleasure in the act of molding and fondling the clay.

Impatient with perspective, Matisse made no attempt to render either objects or people with academic strictness. His rooms often appear foreshortened. Floors slope and tables tilt, making us fear briefly that a bowl or vase may be in danger of crashing to the floor. In the same way, he often painted groups in two dimensions—notably in *The Dance II*, a mural of dancers linked in a ring, commissioned by American millionaire collector Albert C. Barnes in 1932. The flatness and emphasis on color in these works recall both prehistoric cave art and the murals of Minoan Crete, while his later paper cut-outs, with their geometric shapes in primary shades, foreshadow the color field paintings of 1960s Popism.

In 1939, as he turned seventy, Matisse's health began

to fail. In 1941, he survived surgery for intestinal cancer. Leaving his wife of forty-one years, he moved in 1943 to Le Rêve—The Dream, a villa in the hillside town of Vence. He lived there until 1949, cared for by Lydia Delectorskaya, a former model, and by nursing student Monique Bourgeois. Despite Bourgeois's devout Catholicism and Matisse's atheism, she and the artist became close friends. She continued to model for him even after becoming a Dominican nun in 1946. The following year, Matisse agreed to decorate the tiny Chapelle du Rosaire, or Chapel of the Rosary, in Vence.

Back at his home in the Hôtel Regina, he worked for four years designing the entire interior of the chapel, including murals, stained glass windows, the font and even the priests' vestments, which were predictably colorful, in contrast to the starkly minimalist Stations of the Cross, painted in black on the wall. Some regretted the lack of his customary vigor and sensuality in the chapel, but Matisse insisted that "what I have done is to give it, solely by the play of colors and lines, the dimensions of infinity." Too ill to attend the opening in 1951, he sent a message reading, "This work required four years of exclusive and assiduous labor and is the result of all my active life. I consider it in spite of all its imperfections as my masterpiece."

Unable to leave his bed, Matisse turned to "painting with scissors," turning colored paper shapes into "*gouaches decoupées*"—cut-paper paintings. Though mocked at the time as "paper jokes," these are among his most innovative works. The series called

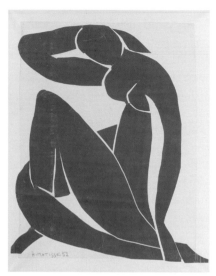

Blue Nude II, Henri Matisse, 1952

Blue Nudes expanded the technique to encompass the female body. In 1947, he produced his most famous work in the form, the book *Jazz*. Initially published in a limited edition of 370 copies, it became one of his most popular creations, although Matisse regretted the way in which printing smoothed out the textures and *pentimenti*— second thoughts—of the originals. However, he was sufficiently grateful to his publisher Tériade to paint a mural on the wall of his villa.

At age eighty-one, Matisse continued to create. Robert Capa shot a photo essay of the old man, working in bed on a table propped across his knees, closely observed by his black cat. Hearing he was bedridden, Picasso and his mistress Françoise Gilot visited him with a gift they knew he would enjoy—a

conjuror who performed tricks just for him. Delighted, Matisse responded by cutting paper portraits of them all.

He died of a heart attack at the age of eighty-four. Though his body lies in the cemetery of the Monastère Notre Dame de Cimiez, adjacent to his villa, his soul might be roaming the oceans he loved. Asked how he expected to be reincarnated, Matisse, with memories of his Tahitian visit, said "I wouldn't mind turning into a vermilion goldfish," and it's as a flash of crimson in the Mediterranean blue that he is most easily and naturally remembered.

Epilogue

The modern Matisse museum, next to the Italianate gardens of the Franciscan monastery, occupies the Villa des Arènes, a seventeenth-century villa overlooking newly excavated Roman ruins. Below the villa, an extensive modern exhibition area documents Matisse's life and work. The olive grove in front of the villa is dedicated to jazz, with busts of famous jazz musicians, including Louis Armstrong and Lionel Hampton, and promenades named for Miles Davis and other exponents.

Le Rêve is now operated as an artists' retreat and study center. The Beau Rivage, where Matisse first lived in Nice, has become a four-star hotel with a private beach, said to be the largest on the Riviera.

The Chapelle du Rosaire in Vence can be visited by appointment. Among those who did so and described it was Sylvia Plath, in 1956 a twenty-three-year-old Fulbright scholar. To her mother, she wrote, "To Vence–small, on a sun-warmed hill, uncommercial, slow, peaceful. Walked to Matisse cathedral–small, pure, clean-cut. White, with blue tile roof sparkling in the sun–I just knelt in the heart of the sun and the colors of sky, sea, and sun, in the pure white heart of the Chapel."

WILD BEASTS, BLUE NUDES AND
HENRY HAIR MATTRESS

Some artists are born to controversy; others have it thrust upon them. Few men were less sensational than Henri Matisse, yet it was he whom the American press and public attacked when, in 1913, a survey of modern European art was presented in the U.S. Before the tour ended, Matisse's work would be put on trial, condemned, and publicly burned.

Matisse had experienced notoriety in 1905 when the annual Paris Salon d'Automne presented work by the Post-Impressionists. "A pot of paint has been flung in the face of the public," snarled critic Camille Mauclair. Organizers exiled the works to a side gallery by a nude statue by Donatello. Louis Vauxcelles, critic for the weekly *Gil Blas*, headlined his review "Donatello parmi les fauves!" (Donatello among the wild beasts!) After Matisse and his friends posed for a photograph around the statue, the group was labeled *Les Fauves*.

Matisse contributed three canvases to the International Exhibition of Modern Art, which opened at the 69th Regiment Armory in Manhattan on February 17, 1913. Before it closed, 90,000 people had viewed its 1,400 works. Few of them left the show indifferent.

Moving to Chicago, the *Daily Tribune* set the tone with its headline: *Splash! Splotch! Cubist Art Here*. However, while Marcel Duchamp's *Nude Descending a Staircase* caused the greatest fuss in New York, in Chicago it was Matisse, in particular his *Nu Bleu: Souvenir of Biskra*.

The painting owed its notoriety to another nude. Detective Fred Hirsch of Chicago's "censor bureau" was passing Jackson & Semmelmeyer's photographic store when he saw a print of a nude woman in the window, and ordered Mrs. Florence Semmelmeyer to remove it. When she refused, she was prosecuted, but a judge threw out the case, accepting that the image was a work of art. The painting was *Matinée de Septembre* (*September Morn*), Paul Émile Chabas's depiction of a girl bathing in a lake at dawn. After being exhibited at the Paris Salon of 1912, it disappeared into a private collection, but found a second life as a cheap lithograph.

Since Matisse's contribution to the show were all nudes, he became a means of continuing the scandal. According to art historian Kimberly Orcutt, Matisse's lumpy, angular, tinted *Blue Nude* struck at the heart of conventional painting by redefining a classic subject.

According to Walt Kuhn, one of the show's organizers, "the teachers at the Art Institute were almost a solid unit against our exhibition, and insisted upon escorting their classes through the various halls and 'explaining' and denouncing every part of the show." Students then put the show on trial. They attacked the museum's executive secretary, Newton H. Carpenter. "He has turned the Art Institute into a circus," asserted one protester. In a letter to William M. R. French, the museum's director, he claimed to have invited the show not out of enthusiasm for modern art but, on the contrary, to alert students to the dangers it represented. Happily, he continued, they learned the lesson. He wrote. "I feel that the exhibition will not only do them no harm but on the contrary will get them conversant with the movement, with which they will have nothing to do."

The attack turned to Matisse, who was tried in absentia at the entrance of the Art Institute. An actor impersonating Matisse, renamed "Henry Hair Mattress," was marched out in manacles, "at the point of a rusty bayonet," according to the *Daily Tribune* A jury heard him accused of "artistic murder, pictorial arson, artistic rapine, total degeneracy of color, criminal misuse of line, general esthetic aberration, and contumacious abuse of title."

When the prosecution showed copies of Matisse's canvases, the jury pretended to faint in horror, and delivered a guilty verdict. The paintings were then burned, and the artist led to his execution. Instead, according to the *Tribune*, "the shivering futurist, overcome by his own conscience, fell dead." Following a mock funeral, a student read a eulogy. "You were a living example of death in life," it proclaimed. "You were ignorant and corrupt, an insect that annoyed us, and it is best for you and best for us that you have died." Before the crowd could burn Matisse in effigy, the police stepped in. The crowd then attacked the dummy. According to the *Examiner*, "Hair Mattress was thoroughly killed and dragged about."

If Matisse knew of this, it didn't concern him. He spent most of 1913 in Tangiers, painting the odalisques that so inspired Picasso. In Chicago, the show closed on April 16. The *Tribune* headlined "Cubists Depart: Students Joyful, Burn Copies of Matisse's Works After Syncopated Art Is Shipped East. Sentence Culprit to Die. Henry Hair Mattress Guilty of Every Artistic Sin on Calendar."

In 2010, the Chicago Art Institute presented the exhibition *Matisse: Radical Invention, 1913-1917*. A gala opening dinner raised $500,000 for the museum. It's not known whether the menu included crow.

DYING TO WRITE: D.H. Lawrence and the Literary Invalids

In his 1918 poem *Futility*, Wilfred Owen writes of soldiers moving a dying comrade into the sun, hoping in vain that its warmth will revive him. "If anything might rouse him now/The kind old sun will know."

Climatotherapy, the theory that disease could be cured, or at least kept at bay, by exposure to sunshine, clean air, seawater or mineral springs, flourished well into the twentieth century. While warmth diminished the pain of arthritis, and alpine or sea air eased the breathing of asthma sufferers or victims of mustard gas, such treatments at best relieved the symptoms. Nevertheless, victims of then-incurable diseases, in particular tuberculosis, flocked to the mountains and seaside.

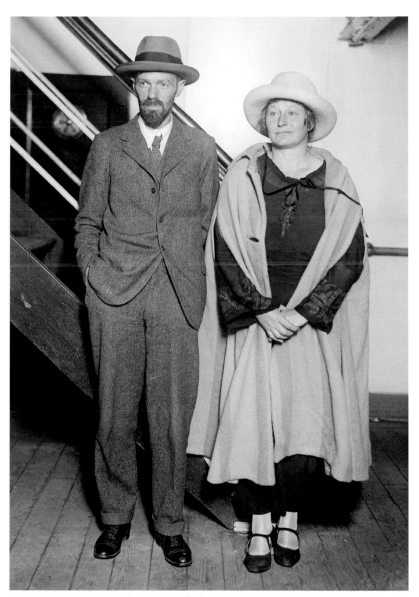

David H. Lawrence, British author, and his wife as they sailed for Europe on the *S.S. Resolute*, 1925

As early as the 1700s, southern France had become a health resort for the upper classes. Nice, wrote historian Paul Gonnet, supported "a colony of pale and listless English women and listless sons of nobility near death." Scots novelist Tobias Smollett, a tuberculosis sufferer, visited the city in 1763. His *Travels Through France and Italy* rather crankily praised its climate and diet. Locals tried to dose him with beef broth or bouillon. They regarded it as more medicine than food, and claimed it could even bring hanged men back to life.

British authors, among them Robert Louis Stevenson, D.H. Lawrence and Katherine Mansfield, visited the French Riviera in hopes of a tuberculosis cure. Stevenson and Mansfield both spent time in Menton. In 1919 and 1920, Mansfield spent long periods in Menton at the Villa Isola Bella where she wrote some of her best work. Sited on the French/Italian border, convenient to both countries, the town attracted patients from each, as well as from Britain. They were encouraged by a British doctor, James Henry Bennet, whose 1870 book *Winter and Spring on the Shores of the Mediterranean* praised the health benefits of the Riviera. Bennet claimed to have suffered from tuberculosis and gone to Menton to die, only to be miraculously cured. "The time is fast approaching," he forecast, "when tens of thousands from the north of Europe will adopt the habits of the swallow, and transform every town and village on its coast into sunny winter retreats."

Guy de Maupassant, docking there in 1887 during a boating holiday, called it "the hospital of society and

Colette Dumas Lippmann, Geneviève Straus and Guy de Maupassant, 1889, by Giuseppe Primoli

the flowery cemetery of aristocratic Europe." Almost ghoulishly, he described the sight on the oceanside promenade of "some poor emaciated creature, dragging himself along with languid step, and leaning on the arm of a mother, brother, or sister. He coughs and gasps, poor thing, wrapped up in shawls notwithstanding the heat, and watches us, as we pass, with deep, despairing, and envious glances."

When an invalid died in Menton, doctors and hoteliers closed ranks to disguise the fact. "Never is a coffin seen in the streets," wrote Maupassant, "never is a death knell heard. Yesterday's emaciated pedestrian no longer passes beneath your window, and that is all. If you are astonished at no longer seeing him, and inquire after him, the landlord and servants tell you with a smile that he had got better and by the doctor's advice had left for Italy. In each hotel Death has its secret stairs, its confidants, and its accomplices."

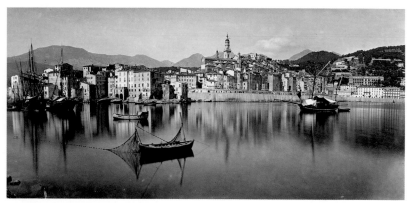

Panoramic view of the town and the harbor of Menton, before 1910, photo by Jean Gilletta

Among those who succumbed in Menton was Aubrey Beardsley, favorite illustrator of Oscar Wilde and a leader of the Decadent movement in British art. He expired at the Cosmopolitan Hotel in March 1898, aged only 25. A late convert to Catholicism, he was buried after a requiem mass at Menton cathedral. In his last days, he begged his publisher to destroy all his "bad," i.e., erotic, drawings. Fortunately this wish was disobeyed.

Robert Louis Stevenson, creator of *Treasure Island* and *Dr. Jekyll and Mr. Hyde*, typified the literary invalids who travelled the world in search of a climate where they could work in comfort. After trying Colorado, California and rural New York, as well as Davos in Switzerland, Stevenson spent his final years in Samoa.

During 1882 and 1883, however, he also visited the Riviera, renting a tiny mock Swiss chalet, perched in

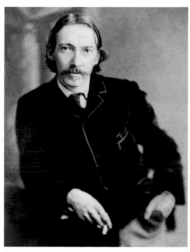

Robert Louis Stevenson, 1880

the hills above Hyères. Bought at the 1878 Paris Exposition and re-erected overlooking the Mediterranean, the Chalet de Solitude was barely large enough for Stevenson and his wife, but he thought it "the loveliest house you ever saw, with a garden like a fairy story and a view like a classical landscape." During sixteen months there, he began *The Black Arrow* and his classic adventure story *Kidnapped*. Years later, he wrote "I was only happy once. That was at Hyères."

At the end of 1929, during a winter of particular severity, the novelist D. H. Lawrence, author of *Lady Chatterley's Lover*, arrived with his wife, Frieda, at the Hôtel Beau Rivage in Bandol, on the eastern side of the Baie des Anges. Katherine Mansfield had also stayed in the same hotel some years before, hoping to be cured. Novelist Aldous Huxley, best known for *Brave New World*, visited Lawrence from his house in nearby Sanary and urged him to consult Andrew

Morland, an expert in lung diseases who had successfully treated some mutual friends in London, including painter Mark Gertler.

Hearing of Lawrence's illness, Morland agreed to take his winter holiday in Bandol in order to examine him. He and his wife arrived in mid-January 1930. "After the examination," she wrote, "my husband talked at length to Frieda, trying to impress on her that what was needed was milk and proper nursing care under medical supervision. We found that the old gardener had a goat and we persuaded him to tether it in the Lawrences' garden and also to milk it; in those days fresh milk was very hard to come by in the south of France. Frieda thought that most illnesses should be cured by a mixture of willpower, exercise, such as swimming at six a.m., and the application of various current fads, like adopting a salt-free diet."

Morland sent Lawrence to Vence, ten miles inland and a thousand feet above sea level, but it was too late to arrest the disease. By the time he arrived, he weighed only eighty-five pounds. He checked into "a sort of sanatorium," which he dismissed as just "an hotel where a nurse takes your temperature and two doctors look after you once a week." H. G. Wells, living in nearby Grasse, came to see him, as did the Aga Khan, but it was obvious to both that Lawrence was dying. Frieda moved him to a more comfortable place but he passed away on March 2, 1930, and was buried in the local cemetery only to be exhumed five years later and his remains cremated to facilitate their transfer to a memorial chapel in Taos, New

Mexico, on the ranch of his patroness Mabel Dodge
Luhan. Frieda Lawrence is believed to have mixed
his ashes into the cement of the chapel foundations.

People in desperately poor health were easy meat
for the quack doctors who congregated on the
Riviera. In Vienna just after World War I, Eugen
Steinach claimed that life could be prolonged in
men by giving them a partial vasectomy and in
women by bombarding their ovaries with X-rays. In
Paris, a doctor named Ivan Manoukhin adapted his
methods, irradiating the spleen as a treatment for
tuberculosis. Katherine Mansfield endured a few of
his expensive and painful treatments, then put
herself in the hands of the mystic George Gurdjieff
and his Institute for the Harmonious Development
of Man near Fontainebleau. Believing she needed to
breathe "richer air," Gurdjieff forced her to sleep in a
barn on his estate. This simply hastened the end.
She died there in January 1923.

Also offering to prolong life, another Russian, Serge
Voronoff, set up a clinic in Menton. Promising that
youth and virility could be restored by transplanting
glands from animals, in particular monkey testicles,
Voronoff opened three clinics in Paris and soon had
a long waiting list of celebrities eager for treatment,
among them the author Anatole France and,
according to rumor, Pablo Picasso.

Voronoff travelled the world, performing surgery on
crowned heads and political leaders. In 1923, when
the French government banned the importation of
apes from Africa, he created two ape farms, one at

Nogent-sur-Oise in the northern region of Picardie, the other in the Chateau Grimaldi in Menton.

The hillside estate at Menton, its giant cages housing as many as fifty animals in the care of a former circus animal trainer, became famous. Celebrity visitors included actress Sarah Bernhardt and impresario Sergei Diaghilev, who went on to Venice and died there from diabetes. Soprano Lily Pons was a frequent guest during her opera seasons in nearby Monte Carlo, and confessed to having been kissed by one of the chimps. The deposed King Carol II of Romania, who lived with his mistress Magda Lupescu in nearby Nice for four years during the 1920s, was probably one of Voronoff's patients.

Menton residents claimed to have seen creatures with the bodies of apes and the faces of men roaming the grounds of Villa Grimaldi; results, they suggested, of attempts to mate the two species. The rumors had a small basis in fact. Voronoff did try to create such a hybrid by transplanting human reproductive organs into an ape but the experiment failed. As his work and that of other researchers in rejuvenation such as Eugen Steinach became increasingly discredited during the 1930s, Voronoff made a judicious retreat to the Americas, where he waited out World War II.

In 1934, sixty-nine-year-old Irish poet and playwright William Butler Yeats underwent the Steinach treatment in London. Others who submitted to the surgery, including Sigmund Freud,

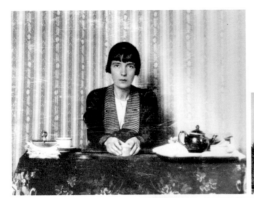

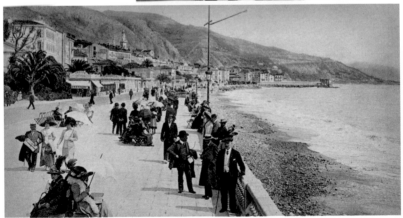

Clockwise from top left: Katherine Mansfield at the Villa Isola Bella, 1920, photo by Ida Baker; Villa Grimaldi; Bertha Georgie Yeats (née Hyde-Lees) and William Butler Yeats, 1930; Vintage postcard of Menton

Promenade en bord de mer (Menton), Évariste Carpentier, 1888

noticed no improvement, but Yeats claimed an immediate return to virility. As he embarked on a series of affairs with younger women, Dublin journalists hailed him as a "gland old man."

The effects of the operation didn't last. Following a relapse in 1935, he wrote "I find my present weakness made worse by the strange second puberty the operation has given me, the ferment that has come upon my imagination." His health continued to decline. In December 1938, he and his wife took refuge from the Irish winter in Roquebrune-Cap-Martin, near Menton. After a series of heart attacks, he died at the Hôtel Idéal Séjour on January 28, 1939.

Epilogue

The Villa Isola Bella in Menton, where Katherine Mansfield lived and worked in 1919 and 1920, is maintained as a museum. A plaque bears a quote from a letter Mansfield wrote to her husband John Middleton Murry. "You will find Isola Bella in pokerwork on my heart."

Aubrey Beardsley was buried in Menton's Cimetiére de Vieux-Château, but the exact location of his grave is unknown.

A plaque in the cemetery in Vence records that "David Herbert Lawrence reposed here from March 1930 to March 1935."

William Butler Yeats was buried in Roquebrune-Cap-Martin. In September 1948, the body, as he wished, was exhumed and reinterred in Drumcliff, County Sligo, Ireland, under the stone with its famous epitaph "Cast a cold eye/On life. On death/Horseman, pass by!" There is no monument at Roquebrune, some controversy about exactly where he was originally interred, and even doubts that the body reburied in Ireland was that of Yeats at all.

Guy de Maupassant's sailing holiday ended tragically in January 1892. Already suffering from terminal syphilis, he experienced hallucinations of being visited by a "grey lady," began to rave, and tried to cut his throat. Though the wound wasn't fatal, doctors took him from the boat to a sanitorium, where he died the following year.

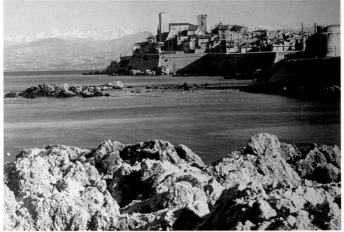

CÔTE D'AZUR
1860-1910
PHOTOS BY
JEAN GILLETTA

Clockwise from top left: Alpes-Maritimes; Menton; Antibes; Ile de Lérins near Cannes

Clockwise from top left: Eze; Alpes-Maritimes; Hôtel Antibes; Nice port; Monaco, arrival of Prince Albert I

CHAPTER 5

FRANK HARRIS: A Life of Love and Lies

Not every exile on the Riviera between the wars resided there because of the climate. Gamblers, smugglers, quack doctors, drug lords, white slavers, secret agents, confidence men and burglars operated freely under the protection of corrupt police forces, with a private yacht always waiting to whisk them to North Africa or Spain if their fortunes should change.

In secluded villas, deposed Balkan kings and Russian grand dukes lived incognito on looted fortunes. "The shores of the Mediterranean were littered with royalties," wrote William Somerset Maugham, "lured by the climate, or in exile, or escaping a scandalous past or unsuitable marriage." American humorist James Thurber, who worked for the Riviera edition of The *New York Herald Tribune* in 1925 to 1926, wrote nostalgically that "Nice, in

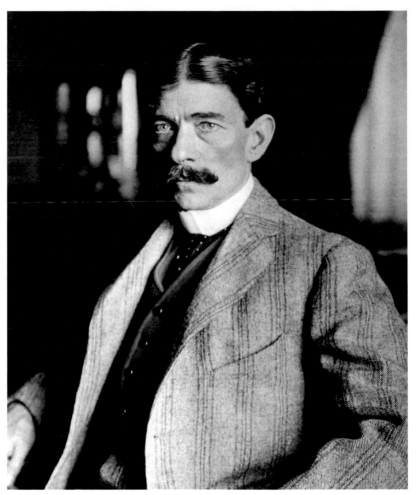

Frank Harris

Following his arrest, Frank Harris makes his way to Brixton Prison, 1916

that indolent winter, was full of knaves and rascals, adventurers and imposters, *pochards* and *indiscrets*, whose ingenious exploits, sometimes in full masquerade costume, sometimes in the nude, were easy and pleasant to record."

Among these rascals was Irish-born novelist, biographer and editor Frank Harris, who wrote "I have known and loved that strip of coast from Genoa to Toulon more years than I care to count." Harris, recalled Thurber, "would often drop in to the *Tribune* office, and we would listen to stories of Oscar Wilde, Walt Whitman, Bernard Shaw, Emma Goldman, and Frank Harris."

Only five feet six inches tall, sharply dressed, with a mass of slicked-back hair and a bushy moustache, waxed, turned up at the ends and, like the hair, suspiciously black, Harris resembled a bantam rooster with the barnyard's loudest crow. Many

detested him. Novelist John Dos Passos called him "an objectionable little man. He was sallow as a gypsy. He had bat ears, dark hair with a crinkle in it that grew low on the forehead, and a truculent mustache. People remarked on the richness of his bass voice. His charm was great, particularly for the opposite sex. He had the gift of the gab to a sublime degree and a streak of deep scoundrelism that was the ruin of him."

Difficult as Harris was to like, particularly if one had been on the receiving end of his exaggerations, he did make his mark in the literary life of his day. *Dracula* author Bram Stoker and novelist Guy de Maupassant were friends, and he socialized with Lord Randolph Churchill, whose son Winston became prime minister. (Harris would later cause a sensation by revealing that both Maupassant and Randolph Churchill died of syphilis, an unmentionable disease at the time.)

Both Oscar Wilde and George Bernard Shaw were close friends, and Harris wrote their biographies. During his time in New York as proprietor of the left-wing *Pearson's Magazine*, he became friendly with Walt Whitman, as well as many leading communists and anarchists, including Emma Goldman. His knowledge of political terrorism informed his novel *The Bomb* (1908).

Harris also wrote two books about Shakespeare, in one of which he speculated that the great playwright might have been gay. Few scholars supported him, but Harris made no apologies. Asked by the press

for his opinion of homosexuality, he boomed "You'll have to talk to my friend Wilde about that—but if Shakespeare had asked, I would probably have submitted."

Three marriages and numerous affairs earned Harris a reputation as a seducer. In old age, he claimed to have enjoyed more than two thousand women. Enid Bagnold, later a noted novelist, boasted of choosing him as the man to whom she wished to surrender her virginity, and of doing so in a room above London's Café Royal, where he often ate and drank with Wilde and his circle.

As James Thurber implies, Harris's life was his own favorite subject. Absconding from school at thirteen, he made his way to New York, where he shined shoes, hauled luggage as a porter, and worked construction on the Brooklyn Bridge. Relocating in Chicago as a hotel clerk, he became, he claimed, a cowboy, driving cattle to and from Mexico until he became bored with that and took a law degree at the University of Kansas.

By 1883, he was back in England as editor of The London Evening News. George Bernard Shaw, its drama critic, said he "blazed through London like a comet, leaving a trail of deeply annoyed persons behind him." When news was thin, Harris told reporters to write up relatively minor crimes in a lurid style, not then seen in the British press. Such headlines as "Extraordinary Charge Against a Clergyman. Gross Outrage on a Female" pioneered tabloid sensationalism.

Harris never stayed long in the same job. According to novelist H. G. Wells, "his dominating way in conversation startled, amused and then irritated people. He was a brilliant editor, for a time, and then the impetus gave out, and he flagged rapidly. So as soon as he ceased to work vehemently, he became unable to work. He could not attend to things without excitement. As his confidence went, he became clumsily loud."

Harris was among those who urged Oscar Wilde to avoid arrest for homosexual offences by fleeing to France. Wilde ignored them, and was jailed. Released in December 1898, he took refuge in a freezing Paris. One of the few friends to remain loyal, Harris paid his debts and spirited him away to the Riviera.

Refusing to live quietly in the hills, Wilde took a hotel room in La Napoule, just outside Cannes, and returned to his old habits. "Even in La Napoule there is romance," he wrote to a friend. "It takes the form of fisher-lads, who draw great nets, and are strangely perfect. I was in Nice recently. Romance there is a profession, plied beneath the moon." On their way to see Sarah Bernhardt playing *Tosca* in Cannes, Wilde startled Harris when he greeted their young boatman by name. Inevitably Wilde was recognized by a guest at his hotel. The management ejected him, and he died shortly after in Paris, but not before dedicating his play *An Ideal Husband*, "To Frank Harris, a slight tribute to his power and distinction as an artist, his chivalry and nobility as a friend."

In 1921, Harris retired to Nice with his third wife Nellie, and returned to pulp journalism, this time with himself as subject. "I want to see," he announced, "if a man can tell the truth naked and unashamed about himself and his amorous adventures in the world."

His memoir, initially called *My Life*, expanded from one volume to four, the last three retitled *My Life and Loves* to accommodate copious details of his sex life. On the first pages, he used the ironic metaphor of marksmanship to chart his failing virility. As a boy, his body was a machine gun, able to fire repeatedly, but without discrimination. In middle age, his aim was better but he had only a double-barreled shotgun at his disposal. And when, in old age, he truly mastered sex, his rifle could manage only a single shot.

No publisher dared accept *My Life and Loves*, so Harris approached Sylvia Beach of the Shakespeare and Company bookshop in Paris, who had financed James Joyce's *Ulysses*. When she turned him down, he asked her to suggest a book to read on the train back to Nice.

Tongue in cheek, Beach said, "Do you know *Little Women*?"

Harris's eyes lit up. "No!" he said. "But it sounds *very* interesting."

What he made of Louisa May Alcott's staid tale of four sisters growing up in rural America is not

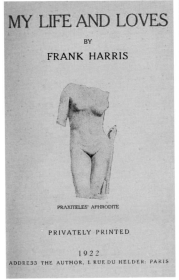

MY LIFE AND LOVES

BY

FRANK HARRIS

PRAXITELES' APHRODITE

PRIVATELY PRINTED

1922
ADDRESS THE AUTHOR, I, RUE DU HELDER, PARIS

Left: *My Life and Loves,* Frank Harris, 1922; Right, Illustrations from the book

known. (In one respect at least, Beach chose well, since some of the book is set in Nice, which Alcott visited in 1868.)

In the end, Harris printed *My Life and Loves* at his own expense in Germany, and sold it by mail, or through shady bookshops in Paris. Customs officers in Britain and the United States burned the copies they confiscated, and charged him in absentia with corrupting public morals. Harris just added erotic illustrations, printed more, and increased the price. Confident the French courts would never prosecute, he boldly signed those sold from his home in Nice, helpfully adding his private Paris address.

My Life and Loves has been called "a deranged monument to egotism [which] destroyed Harris's reputation, crippled him financially and reduced him in the eyes of literary history to a bumptious loudmouth, a man who was little more than vanity wrapped in skin." However, it remains one of the most widely-read and lively of literary memoirs, if also among the least reliable.

Some of Harris's claims, such as having met gunman "Wild Bill" Hickok and witnessing the 1906 San Francisco earthquake, are demonstrably false. As for his life as a cowboy, a colleague who really lived on the Mexican border accused Harris of passing off stories of his life as his own.

His erotic exploits are even more difficult to authenticate. If he did invent a pornographic card game called *Dirty Banshee*, with designs of gods and goddesses fornicating, nobody ever saw it. And though he claimed to have compiled a card index of two thousand sex partners and to have insured it with Lloyd's of London, that too has disappeared.

By 1928, "crippled and condemned and poor," Harris appealed to George Bernard Shaw to let him write his biography, since his one-time drama critic was now an acclaimed playwright. Horrified, Shaw replied "Abstain from such a desperate enterprise! I will not have you write my life on any terms." He finally gave in, while insisting "If there is one expression in this book of yours that cannot be read at a confirmation class, you are lost forever."

Harris died in 1931, before Shaw could approve his text. His widow sold him the galley proofs, which Shaw edited. "I have had to fill in the prosaic facts in Frank's best style," he told her, "and fit them to his comments as best I could; for I have most scrupulously preserved all his sallies at my expense." Even Shaw, not known for restraint, saw there was more honor in a Frank Harris insult than the praise of lesser men.

Epilogue

After Harris's death, Paris publisher Jack Kahane reissued *My Life and Loves,* which became the most profitable book of his Obelisk Press. His son Maurice Girodias, proprietor of the Olympia Press, bought Harris's notes and commissioned Scots writer Alexander Trocchi to ghostwrite a fifth volume. Bibliographer Neil Pearson finds Trocchi's pastiche superior to Harris, praising in particular its "lubricious account of a night spent playing nude leapfrog with teenage girls, all related in a pitch-perfect imitation of Harris's style."

In 1958, the film *Cowboy* loosely adapted Harris's *On the Trail.* The young Harris, then working in a Chicago hotel, goes into partnership with a cattleman, partly to pursue a Mexican beauty whose parents have taken her back across the border. Jack Lemmon plays Harris as a likeable but naively romantic innocent.

Harris and his wife are buried in the Cimetière Sainte-Marguerite, the small, predominantly Anglo-Saxon graveyard adjacent to Nice's Cimetière Caucade. A plaque on his home on rue de la Buffa reads (in translation) "Frank Harris 1856-1931. Irishman, Journalist, Writer, Loyal Guest of the Côte d'Azur, died in this house."

TRAVELING HOPEFULLY: The Blue Train

Unless you owned a yacht, reaching the Riviera across the 750 miles that separated the English Channel and the Mediterranean posed a challenge. During the 1920s, British author Cyril Connolly celebrated the pleasure of driving there along the new autoroutes, "peeling off the kilometres to the tune of *Blue Skies,* sizzling down the long black liquid reaches of Nationale Sept, the plane trees going sha-sha-sha through the open window."

Most people, however, preferred rail. Making her first visit in 1956, American poet Sylvia Plath wrote of France as "in my mind, irregularly squarish, and a line of railway tracks, like a zipper, speeding open to the south, to Marseille, to Nice and the Côte d'Azur." When, in the 1930 film *Monte-Carlo,* Jeanette

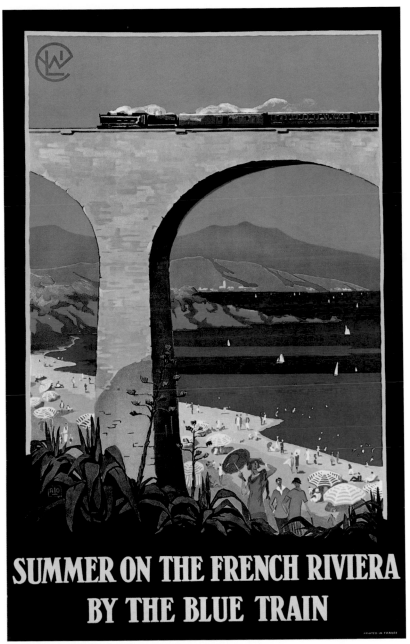

Summer on the French Riviera poster, Charles Hallo, 1925

MacDonald sings that archetypal anthem to the Riviera, *Beyond the Blue Horizon*, she's not in a car but on a train.

Expresses had linked Paris to the Riviera since 1862, managed by the *Compagnie des chemins de fer de Paris à Lyon et à la Méditerranée*, usually shortened to PLM. In every town on the route, a massive *gare* or depot advertised the rule of rail. Temples to transportation, these buildings were designed to flatter the prosperous and awe the impecunious. Under glass roofs supported on webs of cast iron, crystal chandeliers illuminated restaurants and lounges decorated in the swirling and sensuous style known as *Art Nouveau*.

No depot was more luxurious than Paris's Gare de Lyon, which served trains traveling south. When the Universal Exhibition of 1900 brought the best of foreign design to Paris, PLM decided to upgrade the restaurant overlooking its main concourse.

The new restaurant flaunted PLM's domination of the most lucrative rail routes in France. The floors of marble and parquet, the varnished paneling and leather banquettes with brass fittings served merely to set off the lavish decoration of its walls and ceiling. Forty-one original paintings celebrated the destinations served by PLM, including many along the Riviera. Flanking and enclosing the paintings were scores of life-sized nude statues and reliefs— the gods themselves, celebrating travel by train. To demonstrate how highly the government regarded PLM, Émile Loubet, President of the Republic,

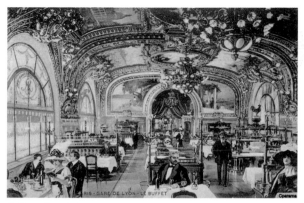
Buffet at Gare de Lyon

officiated at the reopening on April 7, 1901.

World War I stopped tourism dead. Trains once
used for leisure now served the military. Deprived
of their aristocratic clientele, the great hotels and
villas along the Mediterranean became convalescent
hospitals for the wounded, or closed entirely. It
wasn't until 1922 that PLM relaunched its first-
class-only service to the Côte d'Azur. When it did,
passengers joining the train at Calais noted a new
commitment to modernism reflected in its rolling
stock. Gone were the old wooden carriages with
their traditional brown mahogany coachwork. The
cars replacing them were steel, enameled dark blue,
with gold trim. Soon, people were calling the new
express *Le Train Bleu*—The Blue Train. A year later,
PLM made the name official.

From 1922 to 1947, with another interruption for
World War II, The Blue Train collected tourists off
the Channel ferry and carried them overnight to the

Riviera, stopping at Paris, Dijon, Marseille, Toulon, St. Raphaël, Cannes, Juan-les-Pins, Antibes, Nice, Monaco, Monte Carlo, and Menton.

The press was ecstatic about the new service. *Le Figaro* wrote "Going to sleep in a country of mist and grey skies, then waking up the next day to visions of light and sunny places where one breathes a fragrant air: this poetic dream can indeed come true if you take the new lightning-speed train that the Paris-Lyon-Méditerranée company has just created, with Monte Carlo as its destination."

The Blue Train revolutionized rail travel in Europe just as the Super Chief and the 20th Century Limited transformed it in the United States. The

Duke of Windsor on The Blue Train

war might have swept away the grand dukes and crowned heads of the *belle epoque*, but in their place was a new aristocracy: film stars, industrialists, diplomats, and artists. Charlie Chaplin, Winston Churchill, F. Scott and Zelda Fitzgerald, Cole Porter, Sergei Diaghilev, Coco Chanel, Evelyn Waugh and W. Somerset Maugham all patronized The Blue Train.

The service became as fashionable as the Paris-Vienna-Istanbul Orient Express and as prestigious as the transatlantic liners of White Star or Cunard. All of these gave the rich the opportunity to indulge in conspicuous consumption. Although passage on a liner included meals, they paid extra to dine *a la carte* in a luxury restaurant. On their arrival in France, the same people spurned the regular service to the Riviera in favor of The Blue Train—"my dear, the *only* way to travel." When Cole Porter and his wife went south, they booked an entire car; a bedroom for each of them, two more for the valet and maid, a drawing room in which to take their meals and another to entertain friends, or to work.

If The Blue Train appealed to celebrities, it was no less attractive to those who preyed on them. When Agatha Christie's 1928 novel *The Mystery of the Blue Train* assembled a cast of corrupt aristos, jewel thieves and a cross-dressing female music-hall star, nobody accused her of exaggeration. The Blue Train's passenger list invariably included gamblers headed for the casinos of Monte Carlo. As they diverted themselves en route with high-stakes bridge games in the club cars, sleek courtesans—*poules de luxe*—waited to fleece the

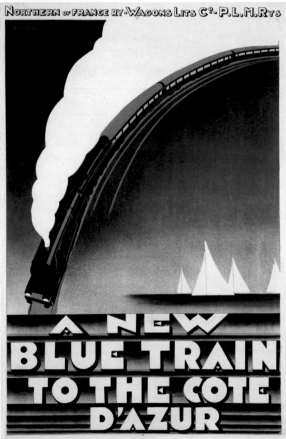

From top: Record sleeve of Darius Milhaud's *Le Train Bleu* illustrated by Albert Brenet;
A New Blue Train to the Côte d'Azur poster, Pierre Zenbel, 1928

winners. With only ten berths to each sleeping car and a team of servants to keep the champagne flowing, few settings were more suited to erotic diversion. Maurice Dekobra's 1927 *The Madonna of the Sleeping Cars* was the first novel to identify these well-traveled adventuresses of the overnight express.

Artists weren't slow to celebrate France's most fashionable train. In 1923, composer Arthur Honegger wrote his orchestral piece *Pacific 231*, the evocation of a railway express, named for the engine that drove it. The following year, Sergei Diaghilev commissioned *Le Train Bleu*, a ballet with music by Darius Milhaud for which Jean Cocteau wrote the scenario, Coco Chanel designed the costumes, and Pablo Picasso contributed one of the most famous of all theatrical curtains—two giantesses skipping exuberantly hand in hand against a Riviera sky.

The Blue Train also inspired creators of advertising art. Railways were always among the leading users of posters. Nothing promoted a holiday better than a vivid image of beautiful people, lightly dressed, posed against picturesque Mediterranean backgrounds, framed usually with garlands of flowers and vines drooping with fruit—the paintings that decorated the Gare de Lyon buffet, but simplified and stylized.

Without skimping on traditional scenes of holiday bliss, poster artists working for PLM also celebrated the train itself. Not the interior, which could be left to the imagination, but the impression it made as

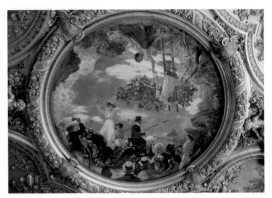

Nice: The Battle of Flowers, Henri Gervex, Le Train Bleu restaurant

it plunged through the countryside. After 1925, *Art Nouveau* gave way to *Art Deco*, the signature style of the period between the two world wars, and one ideally suited to depicting machinery. Ocean liners and express trains were among its artists' preferred subjects. In images of The Blue Train crossing one of the spindly elevated lines that bridged the chasms of the Alpes Maritimes or at full speed on the plains of the Midi, trailed by a plume of vapor— "shoveling white steam over her shoulder" in W.H. Auden's evocative phrase—they made the express appear to embody power and speed.

The Blue Train never revived after World War II. High-rollers in a hurry preferred the aircraft that flew from Le Bourget to Riviera airports, while the new wave of tourists, feeling the pinch of a stronger franc, used the standard service.

Many of the great gares survived the war dilapidated or damaged. Those not torn down in

the 1950s and 1960s were refitted to accommodate a more moderate clientele. There was even talk of demolishing the now down-at-heel Gare de Lyon buffet. Fortunately, in 1963, it was decided to restore it, and to rename it, appropriately, *Le Train Bleu*. In 1972, culture minister Jacques Duhamel guaranteed its survival when he declared it a historical monument.

Epilogue

Races pitting automobiles against trains date back to the earliest days of the twentieth century. Beginning in 1930, a number of cars, in particular the Bentley Speed Six, successfully raced The Blue Train from the Mediterranean to the English Channel.

The Train Bleu restaurant remains one of the sights of Paris. Its paintings represent most of the major PLM lines as well as important personalities and events of 1900. Among the artists who worked on paintings were Charles Bertier, Eugène Burnand, Eugène-Baptiste Emile Dauphin, Gaston de La Touche, Michel Maximilien Leenhardt, Albert Maignan, and Guillaume Dubufe. François Flameng executed *Paris. Villefranche* and *Monaco* are by Frédéric Montenard. Henri Gervex, a friend of Pierre-Auguste Renoir, painted *Nice: The Battle of Flowers* on the ceiling of the Gold Room.

The restaurant is featured in Luc Besson's 1990 film *La Femme Nikita*. Tcheky Karyo takes trainee assassin Anne Parillaud there for what appears to be a graduation dinner, only to present her with a gun (gift-wrapped), and order her to murder the three people sitting behind them.

As recently as the 1970s, the equivalent of sleeping car "madonnas" still worked the Riviera trains. In François Truffaut's 1979 film *L'Amour en Fuite*—Love on the Run, an attractive attorney confesses she can make more money turning tricks on the overnight expresses than trying cases in court.

PLM RAILWAY VINTAGE POSTERS

Clockwise from top left: Paris-Lyon-Méditerranée, Menton, 1904, F. Hugo d'Alési; Antibes, 1890; Winter in Nice, 1896, F. Hugo d'Alési; Monaco-Monte Carlo, 1897, Alphonse Mucha

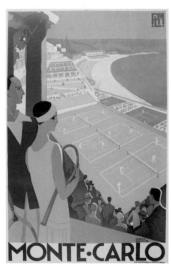

Clockwise from top left: Nice, 1930, Eff d'Hey; Cannes, 1935, Lucien Peri; Monte Carlo, c. 1930, Roger Broders; On the Cote d'Azur, c. 1931, Roger Broders

COCO CHANEL: The Inventor of Everything

In 1923, couturier Gabrielle "Coco" Chanel, stepping ashore at Cannes from the *Flying Cloud*, the yacht of her lover Hugh Grosvenor, the Second Duke of Westminster, startled everyone with her casual shorts and knitted shirt, but, most of all, her suntan. "I think she may have invented sun bathing," sighed Prince Jean-Louis Faucigny-Lucinge—"Johnny" Lucinge to his expatriate friends. "At that time, she invented everything."

Northern Europeans were slow to accept the fashion of suntanned skin, which opponents called "sunburnt." Noël Coward joked about it in his 1930 play *Private Lives*:

Coco Chanel at Villa La Pausa in Roquebrune, French Riviera, with her dog, Gigot, c. 1930

Victor: I hate sunburnt women.
Amanda: Why?
Victor: It's somehow, well, unsuitable.
Amanda: It's awfully suitable to me, darling.
Victor: Of course if you really want to.
Amanda: I'm absolutely determined. I've got masses of lovely oil to rub all over myself.
Victor: Your skin is so beautiful as it is.
Amanda: Wait and see. When I'm done a nice crisp brown, you'll fall in love with me all over again.

Chanel shared Amanda's indifference to the opinion of others. She came up the hard way, raised in an orphanage at Aubazine in the rural south. The bleak architecture of the twelfth-century convent influenced her profoundly. Later in life, she copied the linked "C"s of her logo from a leaded glass window there, and replicated the pattern of its cobbled floors in some of her jewelry. The nuns trained her as a seamstress, a practical trade that celebrated effort and craftsmanship. She began as a hat maker, but when World War I cut off the supply of plumes and other exotic materials, switched to clothes.

At a time when fashion celebrated extravagance and excess, she pioneered simplicity. Faucigny-Lucinge erred in suggesting Chanel "invented everything." Mostly she adapted. Influenced by the first of her English lovers and patrons, Arthur "Boy" Capel, she repurposed the traditional British blazer into a jacket for women, and made dresses from wool jersey, until then used mainly for winter underwear.

From left: Lydia Sokolova, Leon Wyszkowski, Bronislava Nijinska and Anton Dolin in *Le Train Bleu*, 1924; Nora Gregor in *La Règle du Jeu (The Rules of The Game)*, 1939

For headgear, she modified the hats and berets of the French working class. Adding a colorful ribbon to a cheap *canotier* or boater turned it into an object of *haute couture*, with price to match.

Her flair for improvisation made Chanel an ideal costume designer for theater and film. The hats for a 1912 stage version of Maupassant's novel *Bel Ami* came straight from her shop. The robes for a 1922 production of Cocteau's *Antigone* were minimalist, while for Diaghilev's 1924 ballet *Le Train Bleu* she adapted standard knitted swimming costumes of the time. In cinema, she worked only on films with contemporary settings, such as Marcel Carné's *Quai des Brumes* (1938), about infidelity and murder in the world of cheap vaudeville, and Jean Renoir's country house-party satire *La Règle du Jeu* (1939).

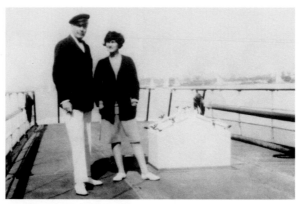

Coco Chanel and the Duke of Westminster on his yacht, 1928

(Renoir's assistant director, the young Milanese Count Luchino Visconti, became a lifelong friend.) In 1930, producer Samuel Goldwyn invited her to design costumes for Hollywood, but found her gowns too plain. When he pressured her to make them more elaborate, she refused. For Chanel, simplicity and style were synonymous.

The newly suntanned Chanel who stepped ashore at Cannes in 1923 was forty years old. Established as a couturier, she was about to market her first fragrance, Chanel No. 5. Confident that anything she did would immediately become the fashion, she launched a line of vacation wear adapted from the loose working clothes of sailors, already discovered by American expats Gerald and Sara Murphy.

Sailing the Mediterranean with the Duke of Westminster, known to his friends as "Ben'dor" or Bennie, she persuaded him they needed a

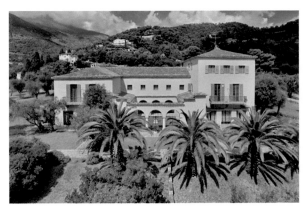
Villa La Pausa

permanent Riviera home. They chose an old
farm surrounded by olive trees on Roquebrune-
Cap-Martin, the headland marking the border
between Menton and Monaco. A former hunting
preserve of the Monegasque royal family, it not
only commanded panoramic views over the
Mediterranean but was almost entirely unoccupied,
guaranteeing privacy.

Chanel also responded to the site's mystical
character. The farm occupied five acres—her
lucky number, and the reason she called her new
perfume No. 5. Once she heard the legend that Mary
Magdalene rested at Roquebrune while fleeing
from Jerusalem following the crucifixion, she was
convinced. Thereafter, the site and the villa she built
on it were known as *La Pausa*—The Pause.

Chanel and the duke planned to keep the three
existing farm buildings, adapting one into the

main house and refurbishing the others for guests. They changed their minds after the Comte Jean de Segonzac, a neighbor, urged them to meet Robert Streitz, a local architect, still in his twenties, who had converted one of his houses. The painter Francis Picabia was living in Cannes. For a show there in 1928, the duke docked the *Flying Cloud* in the harbor and held a party on board. Chanel invited Streitz, who persuaded her to demolish the farmhouse and create a villa appropriate to her role as an arbiter of fashion.

Her imagination engaged, Chanel sent Streitz to the orphanage at Aubazine with instructions to copy the curving stone staircase that linked its upstairs dormitories to the ground floor workrooms. A similar staircase became the focal point of La Pausa, while the interior design replicated Aubazine's beige and white walls. The stairs remained undecorated, a reminder of the most important lesson of Chanel's convent life—the value of simplicity.

At least once a month, Chanel came down from Paris to monitor progress on the villa. At her direction, the rooms were heated with open fireplaces, and filled with objects from her art collection. Streitz covered the bedroom walls in seventeenth-century paneling, stripped back to the original oak. His design included seven bedrooms, since the house soon became a mecca for her friends, some of whom stayed for months. Jean Cocteau, Salvador Dali, Pablo Picasso and Luchino Visconti all spent long holidays there.

Once she broke up with the Duke of Westminster in 1932, Chanel also felt free to entertain new lovers and invite old ones to stay for extended periods. Among the latter, composer Igor Stravinsky and poet Paul Reverdy visited often. (It's now believed that the aphorisms attributed to Chanel, e.g., "How many cares one loses when one decides not to be something but to be someone," were actually composed by Reverdy.) Among her active lovers, Paul Iribe, Paul Poiret's one-time chief illustrator, was still sharing her bed when he died at La Pausa in 1935, supposedly after a strenuous game of tennis.

During World War II, Streitz, working for the anti-Nazi resistance, hid downed fliers and Jewish refugees in the cellar. Apparently unaware of this, Chanel often visited La Pausa with her German lover, Hans Gunther von Dincklage, with whom she also shared an apartment at the Ritz in Paris. Thirteen years her junior, the handsome Dincklage supervised the French fabric industry, making him a valuable catch for a fifty-eight-year-old woman in the clothing business. When photographer Cecil Beaton criticized the relationship, she responded, "Really, sir, a woman of my age cannot be expected to look at his passport if she has a chance of a lover."

Accused of collaboration after the war, Chanel was cleared with suspicious speed, thanks to Winston Churchill, her unashamed admirer. In 1927, he had joined the Duke of Westminster and Coco for a week of fly fishing. To his wife Clementine, he wrote "She fishes from morn till night, & in 2 months has killed

fifty salmon. She is vy agreeable—really a gt & strong being, fit to rule a man or an Empire. Bennie vy well & I think extremely happy to be mated with an equal—her ability balancing his power."

After Chanel sold La Pausa in 1953, Churchill was a frequent guest of the new owners, literary agent Emery Reves and his wife Wendy. He often stayed for months, to paint and to work on his books, in particular his four-volume *A History of the English-Speaking Peoples*. Reves's percentage of its sales as Churchill's agent generated the money to buy the villa.

"We put an entire floor of La Pausa at the disposal of Sir Winston," said Wendy Reves. "He had a large bedroom there; Anthony Montague Browne, his private secretary, an office; Lady Churchill, her own suite; and there were numerous guest rooms. They were never empty while Churchill was at the villa. He could invite anybody, and he did." His guests included the Duke and Duchess of Windsor, German President Konrad Adenauer and General de Gaulle.

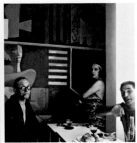

From left: Villa E-1027: Le Corbusier and wife with Romanian architecture critic Jean Badovici at Villa E-1027, photo by Eileen Gray

La Pausa is not the sole building of significance in Roquebrune-Cap-Martin. Villa E-1027, the modernist, minimalist home built in 1929 by furniture designer Eileen Gray, is regarded as a significant work of modern architecture. Architect Le Corbusier stayed there often, but offended Grey by painting seven frescos without her permission. (As a lesbian, she found the motif of kissing women offensive.) No longer welcome as her guest, Corbusier built his own holiday retreat near the seafront—the only building he ever constructed for his private use. A modest *cabanon* or beach hut, it was completed in 1952 strictly according to the principles of his Modulor theory, based on the proportions of the human body. Plans to create a holiday village of similar huts were never realized.

Epilogue

When Wendy Reves died in 2007, her will stipulated that La Pausa and its contents be liquidated to fund her Reves Foundation. "Money is our objective," she wrote. "Every item at La Pausa has value. Even the antique kitchen utensils plus a marble table in the kitchen, for which I was offered $40,000 from one of the great chefs of France." Somewhat rundown and in need of renovation, the villa remains unsold with a price tag of $53 million. It is not open to the public.

Villa E-1027, also dilapidated, is in the process of restoration.

The Roquebrune tourist office runs daily two-hour guided tours of Le Corbusier's *cabanon*, except in July and August. After his 1965 death by drowning, he was buried in the local cemetery under a monument of his own creation. The two-hour walk along the cliffs between Roquebrune-Cap-Martin and Menton has also been named the Promenade Le Corbusier.

TO DANCE AND DIE:
Ballet on the Riviera

Ballet hasn't traditionally flourished on the Riviera. The two events most associated with the Côte d'Azur and dance, one fictional, the other real, both involve the violent death of their central figure, in each case a female dancer.

San Francisco-born Isadora Duncan is often credited with inventing modern dance but the claim must be taken on trust, since, aside from some sketches by Abraham Walkowitz and a few still photographs, her work is undocumented. She always refused to be filmed, even luring photographer Edward Steichen all the way to Greece with a promise to dance at sunrise around the Acropolis, only to refuse at the last moment. According to Steichen, "she didn't want her dancing recorded in motion pictures but would rather have it remembered as legend."

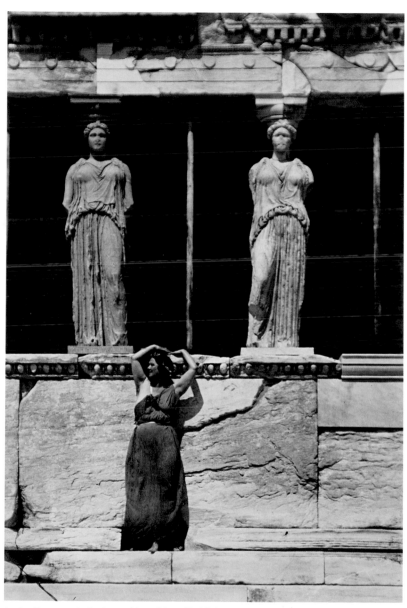

Isadora Duncan at the Parthenon, Athens, Edward Steichen, 1920

As young as six, she was teaching local children her version of dance. To her, it was a self-expressive art that shunned the childish fantasies of nineteenth-century ballets, their formal steps and traditional tutus and toe shoes. In her improvised performances, Duncan always danced barefoot and in loose clothing that showed off a figure too ample for classic dance.

In Paris, she inspired sculptor Auguste Rodin to sketch her but, to her life-long regret, passed up the opportunity to surrender her virginity to him. Befriended by fellow American Loie Fuller, whose dances with flowing veils harmonized with her style, Duncan toured Europe. Her reputation established, she formed a combined school and dance troupe, The Isadorables, and embarked on a crusade to bring modern dance to the world. In doing so, she left a trail of catastrophic marriages, affairs with both men and women, and more than her share of tragedies, including the drowning of her two children and their nanny in a car accident. In 1925, it was only by chance, during an interview with American journalist James Thurber, that she learned her former husband, Russian poet Sergei Yesenin, had hanged himself.

By her forties, Isadora was an overweight near-alcoholic, scratching a living around Paris. When she confessed to painter Tsuguharu Foujita, her neighbor in Montparnasse, that she was down to her last bottle of champagne, he invited her to teach him the foxtrot and tango at the rate of one bottle per lesson. Despite being dismissed by poet Dorothy Parker with the nickname "Duncan Disorderly," she

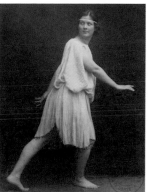
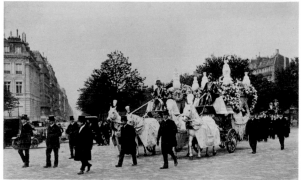

Clockwise from top left: *Isadora Duncan*, Auguste Rodin; Isadora Duncan, 1903-04, Elvira Studio; The funeral of the two children of Isadora Duncan in Paris, 1913

had not lost her capacity to allure. At a party given by Gerald and Sara Murphy in 1927, Zelda Fitzgerald became so incensed at the attention her husband Scott was paying to Duncan that she threw herself down a flight of stairs.

After this, like many other lost souls, Duncan gravitated to the Riviera, becoming a permanent

houseguest of wealthy friends, generally on the pretext of needing peace and quiet to complete the autobiography that would make her fortune. The culminating tragedy of her career and her life took place in Nice in 1927. As she set out in an Amilcar sports car, anticipating an amorous night with its driver, her long hand-painted silk shawl caught in the hub of a rear wheel, jerked tight, pulled her out of the car and broke her neck.

Jean Cocteau, a friend and admirer, praised her audacity. "The details hardly mattered to her. She did not narrow her eyes like an artist, and she did not stand back. She wanted to live massively, beyond beauty and ugliness, to seize hold of life, and live it face to face, eye to eye. She belonged to the school of Rodin. Here was a dancer who did not much care if her dress slipped and revealed shapeless shapes, if her flesh trembled or if sweat ran down her. All these things lagged behind her inspiration." At the same time, Cocteau couldn't resist dashing off a quick sketch of her as he'd last seen her in Nice; chubby, with double chins, her body draped in something baggy; the embodiment of the "shapeless shapes."

In the 1948 film *The Red Shoes*, fictional ballerina Victoria Page meets an end as violent as that of Isadora. Played by Moira Shearer, Page, torn between love for her composer husband and the Svengali-like influence of her impresario Boris Lermontov, throws herself under a train.

Michael Powell and Emeric Pressburger based their film on the real-life relationship of Sergei Diaghilev

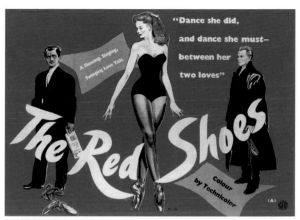

The Red Shoes movie poster, 1948

and schizophrenic dancer Vaslav Nijinsky, who
was also his lover. In 1913, Diaghilev summarily
dismissed Nijinsky from the company after he
announced his marriage, just as Lermontov drives
away the composer Julian Craster in *The Red Shoes*
when he learns of his affair with Vicky. In one of
many additional parallels, the choreographer Lubov
in *The Red Shoes* is played by Leonide Massine, who
succeeded Nijinsky in Diaghilev's bed.

A victim of his artistic ambition, Sergei Diaghilev
lived in constant debt. The ballets of his Paris
seasons of 1907 and 1908 swept away the stodgy
staging, cliché costumes and complacent performers
that Isadora Duncan also detested. Innovation,
however, cost money. The designs of Léon Bakst
and Alexandre Benois for such spectacles as
Schéhérazade, Prince Igor and *Le Spectre de la Rose*
demanded newly painted sets, gilded and brocaded

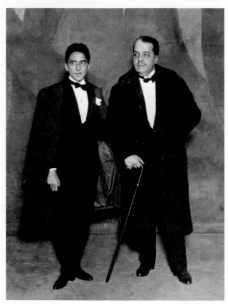

From top: Jean Cocteau and Sergei Pavlovich Diaghilev, 1924; Vaslav Nijinsky in *Schéhérazade*, 1910

costumes as intricately tailored as a *haute couture* gown, and, above all, the gifted people to perform in them.

Diaghilev's eighty-strong company devoured every penny of profit and saddled him with debts from which he never escaped. Beggared by Paris, he took refuge in the traditional playground of the Russian aristocracy, the Riviera. In 1910, his Ballets Russes relocated in Monte Carlo, which, aside from the period of World War I, when he took refuge in Rome, remained its headquarters until Diaghilev's death in 1929.

Each night he could be found at the Café de Paris on the Place de Casino. There he negotiated with foreign managements, refereed arguments between his temperamental collaborators, and coaxed money from such patrons as the American-born Princess de Polignac and the eccentric crossdressing Etienne de Beaumont. *The Red Shoes* reflects that existence, with Lermontov and his creative team roosting in hotels and borrowed chateaux, surviving on their wits and the patronage of wealthy Philistines.

Some of the most striking scenes in *The Red Shoes* evoke the Riviera. When Lermontov brings his company to Monte Carlo, Vicky stays at the Hôtel de Paris and dies near the railway station where, according to legend, the casino management parked the corpses of any unlucky gamblers who had the bad taste to shoot themselves on its steps.

Michael Powell knew the Riviera well. His father

owned a small hotel in Nice, so he grew up surrounded by cultured people of every nationality, most of them living beyond their means. This knowledge informed such scenes in *The Red Shoes* as those shot in the Villa La Leopolda in Villefranche-sur-Mer, an architectural white elephant, which the Duke and Duchess of Windsor once considered as a possible home.

Gowned like a princess from a fairy tale, complete with crown, Vicky ascends the weedy staircase of the apparently ancient and abandoned mansion to be told she is to star in the ballet of *The Red Shoes* that will make her reputation but also lead to her death. Powell stages the scene with just the right amount of fantasy, disguising the fact that the villa, far from being antique, was only completed in 1931.

He introduces a darker note in a night scene of Julian and Vicky cuddled in the back of an open carriage somewhere along the Corniche that wove through the towns of the Riviera. "One day when I'm old," says Julian, "I want some lovely young girl to say to me, 'Tell me, where in your long life, Mr. Craster, were you most happy?' And I shall say, 'Well, my dear, I never knew the exact place. It was somewhere on the Mediterranean. I was with Victoria Page.' 'What?' she will say. 'Do you mean the famous dancer?' I will nod. 'Yes, my dear, I do. Then she was quite young, and comparatively unspoiled. We were, I remember, very much in love.'" Even as he says it, we sense both are aware their story will end in tragedy.

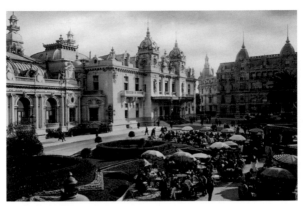

Monte Carlo—The Casino Terrace Café de Paris and Hotel, 1921

Unlike Anton Walbrook's unfailingly dapper
Lermontov, Diaghilev in the 1920s was visibly in
decline. His trademark silk hat had lost its sheen
and the beaver fur collar on his long coat was
showing bald patches. The diabetes, which he
refused to treat, sapped his energy and caused
painful skin lesions. In hopes of a cure, he
approached Serge Voronoff at his Menton clinic,
where his fellow Russian promised new life by
transplanting glands from monkeys, but the damage
of long neglect could not be reversed. He died in
August 1929 in Venice, too poor to pay his hotel bill.

In Diaghilev's time, Monaco was not on the ballet
circuit, but when the Ballets Russes reformed in
1932, the company renamed itself Ballet Russe
de Monte Carlo. Massine and George Balanchine
were hired to choreograph new work but the
company struggled without Diaghilev's autocratic
management, then fragmented in a flurry of lawsuits
over ownership of both the Diaghilev ballets and the

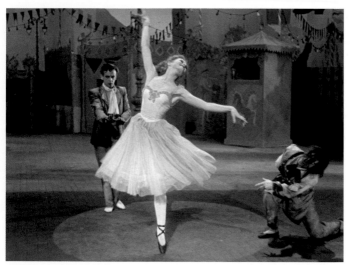

Moira Shearer in *The Red Shoes*, 1948

company's name. On one London tour, companies of both the Les Ballets Russes and the Ballet Russe de Monte Carlo could be found presenting feuding performances at theaters almost in sight of one another. During a tour of Cuba, there was so little money that dancers had to work part-time in nightclubs and revues. The last company to perform under the name Les Ballets Russes expired, bankrupt, in 1951.

Ballet didn't revive in Monte Carlo until Princess Grace, the former Grace Kelly, agitated for the formation of a permanent company. After her death in 1982, her eldest daughter Caroline, Duchess of Hanover, carried on the project. The Ballets de Monte Carlo was officially launched in 1985. Though

most of its repertoire is new work, it still revives the occasional Diaghilev classic. As for *The Red Shoes*, despite being attacked by the ballet community on its first release, the film has flourished. It is consistently rated in international polls as one of the greatest movies on the arts.

Epilogue

Isadora Duncan was cremated and her ashes deposited in the columbarium of the Cimetière du Père Lachaise, Paris (Division 87, urn 6796). Her autobiography, rambling, inaccurate but often riveting, was published posthumously as *My Life*.

Sergei Diaghilev is buried on the cemetery island of San Michele, near Venice, as is Igor Stravinsky.

THE LAST WORDS OF ISADORA?

When Shakespeare wrote of a victim in *Macbeth* that "Nothing in his life became him like the leaving it," he might have been speaking of Isadora Duncan. More than eighty years later, the details of the dancer's death and in particular her last words remain uncertain, with each decade adding a new layer of legend.

On September 14, 1927, the fifty-year-old Duncan was staying with American journalist Mary Desti in the studio of her home in Nice. Her fortunes were improving. Her autobiography *My Life,* completed with financial help from her divorced husband Paris Singer, heir to the sewing machine fortune, was soon to be published. Singer, whom she called "Lohengrin," after Wagner's operatic hero, was visiting her that day, bringing a cheque.

Duncan had also fallen for handsome forty-year-old racing driver Benoît Falchetto, whom she spotted at Tetou, a fashionable restaurant. As he roared off in his Amilcar Grand Sport which Duncan mistook for a Bugatti, she left a card with the maitre d', addressed to a misspelled "Buggatti," inviting him to call, hinting she might want to buy it. A few days later he responded, and they made a date at the studio for five that afternoon.

"You see what a little happiness does," Duncan told Desti that morning. "Stick on the job, Mary, and we'll ride to glory, I promise you."

This comment and most details of Isadora's remaining hours have an unreliable source, Mary Desti. According to her son, film director Preston Sturges, she had no conception of truth: "Anything she had said three times, she believed fervently. Often, twice was enough."

According to Desti, Duncan's afternoon tryst was a disaster. Singer arrived to find her with Falchetto. Snarling "I see you haven't changed," he stormed out, taking her cheque. "I've lost 'Buggatti' and 'Lohengrin' too," Isadora lamented to Desti, but brightened as she confided that Falchetto had agreed to return that night.

Earlier, Isadora dined with Desti and American poet Glenway Wescott, whom she'd asked for help with *My Life.* As Falchetto arrived at nine and Duncan climbed into the Amilcar, Desti offered her a cape, but Duncan preferred her shawl.

Made by Russian-born Roman Chatov, costume designer for Florenz

Ziegfeld, the red *batik* shawl was two yards long and five feet wide, with eighteen-inch fringe at each end. Isadora wore it wrapped around her upper body, with the fringes trailing.

The fabric was "heavy crêpe," wrote Desti, "with a great yellow bird almost covering it, and blue Chinese asters and Chinese characters in black…a marvelous, lovely thing; the light of Isadora's life. She would go nowhere without it." Desti said Isadora told her, "This shawl is magic, dear. I feel waves of electricity coming from it. What a red! The colour of heart's blood."

As she and Falchetto drove off, headed for a hotel, Duncan said, according to Desti, "*Adieu, mes amis. Je vais à la gloire!*" ("Farewell, my friends. I go to glory!") Wescott remembered it as "*Je vais à l'amour*" ("I am off to love"), and Desti later admitted she'd lied, hoping to disguise the couple's true plans.

The official *New York Times* account did the job for her, making Falchetto a hired chauffeur and Duncan an unlucky tourist.

"After an evening walk along the Promenade des Anglais about ten o'clock, she entered an open rented car, directing the driver to take her to the hotel where she was staying. The automobile was going at full speed when the scarf of strong silk suddenly began winding around the wheel and with terrific force dragged Miss Duncan, around whom it was securely wrapped, bodily over the side of the car, precipitating her with violence against the cobblestone street. She was dragged for several yards before the chauffeur halted, attracted by her cries in the street. Medical aid immediately was summoned, but it was stated that she had been strangled and killed instantly."

While Paris Singer arranged the funeral, Duncan's body lay in Desti's studio. "I've never known so beautiful a place as it was that night," wrote Wescott, "in that great bare room, in the midst of the flowerbed, fenced with the church candles she had such a weakness for, under a veil and the famous old purple cloak, the beautiful worn-out old body with the hands folded on its belly. Whenever I think of it as long as I live, a heartbreaking scent and a sort of smoke will rise from the bottom of my heart."

Not everyone was so compassionate. On hearing about the part played by her shawl in Duncan's death, Gertrude Stein simply sniffed "Affectations can be dangerous."

MANY FÊTES:
The Hôtel du Cap and Tender Is the Night

"On the pleasant shore of the French Riviera, about half way between Marseille and the Italian border, stands a large, proud, rose-colored hotel. Deferential palms cool its flushed facade, and before it stretches a short dazzling beach. Lately it has become a summer resort of notable and fashionable people."

F. Scott Fitzgerald was right to begin *Tender Is the Night*, the finest of all Riviera novels, with this description of the Côte d'Azur's most exclusive hotel. He calls it Gauss's Hotel des Etrangers—the Hotel of Foreigners—but the name, like the beach, is a fiction. Disdaining the democracy of sand, guests at the Hôtel du Cap swim in a heated saltwater pool hewn from the granite of the headland, its water replenished with each wave that crashes on the rocks.

First edition cover of *Tender Is the Night*, 1934

From top: Hôtel du Cap D'Antibes; The Eden Roc pavilion and seawater pool, 1932

The founder of the newspaper *Le Figaro*, Hippolyte de Villemessant, built the Villa du Soleil in 1869 as a refuge for authors suffering from writer's block. As successful writers didn't need such a place and the unsuccessful couldn't afford it, his plan flopped. In 1889, he reopened the villa as a simple hotel, named Hôtel du Cap. At this it also failed. Visitors to the Riviera came to see and be seen, not to doze in seclusion. Business dwindled until the staff of forty served a mere two guests—a pair of elderly English ladies who paid the minimum rate of twelve francs a day. Each morning, the manager sent a horse-drawn omnibus to the railway station in hopes of new clients, but it invariably returned empty.

The hotel was rescued by American newspaper-owner James Gordon Bennett, who wanted a place

for his recently widowed sister to grieve and recover in peace. Rather than bother with weekly bills, he slapped down 40,000 francs and told the proprietor to let him know when that was used up. (The principle of accepting payment only in cash became a tradition. Until the early 2000s, the Cap refused credit cards.)

Bennett's intervention persuaded the hotel to promote seclusion as an asset. Where better for a crowned head to relax incognito, a celebrity to enjoy a holiday untroubled by fans, or an illicit couple to consummate a clandestine liaison? The approach to the hotel through a private wood guaranteed secrecy, while deep water just offshore and a dock at the base of the cliff allowed passengers to debark from their yachts with a stealth impossible at the Carlton.

Privacy, however, only went so far. In 1903, Lord William Onslow, a regular guest, was being taken to the station by the owner when they fell to discussing the hotel's lack of central heating, elevators, and *en suite* bathrooms. Before he boarded the train, Onslow bought the hotel outright and ordered the necessary improvements.

After renovations, occupancy rose, and with it the rates. In 1914, the hotel added its outdoor pool. A second building, the Eden Roc pavilion, at the very tip of the headland, provided an indoor pool and restaurant. In addition, thirty-three private cabanas appeared along the cliff edge and among the umbrella pines. These semi-permanent huts with

couches and bathrooms, available only by day and intended as places to change before and after a dip, quickly assumed other functions. Jean Cocteau's 1924 ballet *Le Train Bleu* tipped a knowing wink when it showed illicit couples slipping away into similar hideaways for a little afternoon delight.

Although the hotel originally closed from May to October, it began cautiously to extend its season after wealthy expatriates Gerald and Sara Murphy, house hunting in the area, persuaded the owners to keep one wing open through the summer of 1923. Once F. Scott and Zelda Fitzgerald rented a villa in nearby Lescure, they hung out at the hotel, which became an informal clubhouse for sun-birds. Not that its amenities saw much use. "At the most gorgeous paradise for swimmers on the Mediterranean," lamented Fitzgerald, "no one swam any more, save for a short hangover dip at noon." For the Fitzgerald/Murphy set, a hangover came with the territory. If you weren't behaving badly, you weren't doing it right. In *Tender Is the Night*, Dick Diver yearns for the dramatic squalor of a "bad party, where there's a brawl and seductions and people going home with their feelings hurt and women passing out in the cabinette de toilette."

Among the first celebrity guests was General Charles de Gaulle, who spent his honeymoon there in 1921. As word spread of this trendy new holiday spot, more artists and movie people drifted in. "That summer there was no one in Antibes," wrote Fitzgerald drily, "except..." and here he reeled off a list of illustrious names: film-star Rudolph Valentino

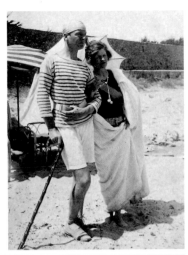

From top: Gerald and Sara Murphy on La Garoupe Beach, Antibes, 1926; F. Scott Fitzgerald, Zelda and daughter "Scottie" at Antibes, 1926

and his choreographer wife Natacha Rambova; director Rex Ingram with wife and star Alice Terry; crime novelist E. Phillips Oppenheim; cabaret queen Mistinguett; poet Archibald MacLeish; Hollywood writer Charles Brackett; socialite Étienne de Beaumont; novelist John Dos Passos and humorist Donald Ogden Stewart, both returning from having run with the bulls in Pamplona in company with Ernest Hemingway. "Just a real place to rough it,"

concluded Fitzgerald ironically, "to escape from the world."

It was at the Hôtel du Cap that Zelda Fitzgerald exhibited the first signs of her accelerating slide into bipolar disorder. After a dinner party, she would demand that Scott drive her there, and, stripping off her evening gown, dive near-naked into the ink-black sea. Scott followed, but gingerly—more proof to her of his dubious virility.

Further to taunt him, she began an affair with a flier from the air base at Fréjus. ("He was bronze and smelt of the sand and sun," she wrote in her autobiographical novel *Save Me the Waltz*. "She felt him naked underneath the starched linen. She didn't think of [her husband]. She hoped he hadn't seen; she didn't care.") The night the affair ended, Zelda overdosed on sleeping pills. Called to the hotel by a frantic Scott, the Murphys took turns walking her for hours until the effects of the drugs wore off.

The stock market crash of 1929 drove most American expatriates back home. Abandoning his ambition to paint, Gerald Murphy returned to New York to resume control of the family business. After an abortive attempt by Zelda to train as a ballet dancer, the Fitzgeralds too went back home, where Zelda was hospitalized with schizophrenia. Scott's epitaph for those lost Riviera summers, *Tender Is the Night*, appeared in 1934. While dedicated to the Murphys in recognition of their generosity and hospitality ("Gerald and Sara—many *fêtes*"), the novel depicted a couple who, though superficially

resembling them, exhibited a tormented sexual and psychological history closer to that of the Fitzgeralds. Gerald was philosophical about the book but Sara saw it as the worst kind of betrayal.

The Americans might have left the Riviera but the fashion to spend summers on the Côte d'Azur was firmly established. Now it was Picasso and Cocteau who visited the Hôtel du Cap, leaving sketches in its guest book. Winston Churchill visited to relax and indulge his hobby of painting. The Duke of Windsor (the former King Edward VIII of England, who gave up the throne to marry American divorcee Wallis Simpson) stayed there with his new wife while they shopped for a villa.

It was late in the 1930s before Americans returned in numbers, and for a year or two life on the headland reverted to the golden days of a decade before. Few seasons were more glittering or dramatic than the summer of 1939. Among the hotel's guests that June were film star Marlene Dietrich and Joseph Kennedy, the former movie mogul recently

From left: Joseph P. Kennedy Jr., Joseph P. Kennedy Sr., and John F. Kennedy, 1938; Marlene Dietrich at Hôtel du Cap, 1938

appointed U.S. ambassador to Britain. Kennedy and Dietrich continued the affair they'd begun the year before in the anonymity of its cabanas. At a party thrown by socialite Elsa Maxwell, Dietrich also ensured that her lover's twenty-one-year-old son John would always remember the occasion. As she and the future president of the United States danced to the year's big hit, Cole Porter's *Begin the Beguine,* she slipped her hand into his trousers.

Reality intruded with the arrival from Berlin of Dietrich's director and lover Josef von Sternberg. He brought embassy gossip of an impending non-aggression pact between Germany and Russia. Cutting short his holiday, Kennedy and family hurried back to London. Stalin and Hitler signed their pact on August 23. On September 1, Germany invaded Poland. Once the war moved into France, the Nazi-backed puppet government made the Hôtel du Cap its Riviera headquarters.

Having ridden out the occupation, the hotel received a transfusion of customers with the relaunch in 1946 of the Cannes Film Festival. The influx of wealthy foreign celebrities reinforced the air of distinction. Privacy became an even more potent selling point. Reporters never got past the front gate and aliases were standard—all signifiers of an old-fashioned snobbery that clients relished. Always impressed by "notable and fashionable" people, F. Scott Fitzgerald would have approved.

Epilogue

After beginning their affair during the production of *Cleopatra* in Rome in 1963, Elizabeth Taylor and Richard Burton continued it at the Hôtel du Cap, where they also spent their honeymoon.

In 1960, when John F. Kennedy, then president, seized the opportunity of a visit by Marlene Dietrich to the White House to enjoy a "quickie," he asked if she'd ever slept with his father. Dietrich, fearing some Oedipal conflict, lied, telling him "He tried, but I refused." JFK said with satisfaction "I always knew the son of a bitch was lying."

Jacques-Henri Lartigue's noted color photograph of his wife Bibi at a sunlit table overlooking the sea was taken in the restaurant at the Eden Roc.

VILLA NOAILLES: Cement, Celluloid and Surrealism

In 1923, citizens of the Riviera village of Hyères watched in consternation as a massive villa took shape on the hillside above the town. At a time when even new houses used wood, brick, tile and stucco, the white concrete box rising from the ruins of the chateau of St. Bernard was a disturbing sign of imminent change.

The villa was commissioned by the newly-married Vicomte and Vicomtesse Charles and Marie-Laure de Noailles, who received the land as a wedding gift. With the marriage, Marie-Laure's family, the Bischoffscheims, provided much-needed capital to the land-rich but cash-poor Noailles, not to mention hopes of an heir to carry on their distinguished name. (They were disappointed: the marriage produced two girls.)

Luis Buñuel 's *L'Age D'Or*, 1930

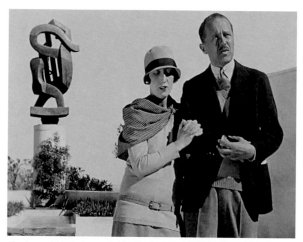

Charles and Marie-Laure de Noailles in *Biceps and Jewellery*, 1928, directed by Jacques Manuel

It was an improbable alliance. Charles disliked Paris, preferring to design gardens, on which he was a world authority. Nor did he measure up sexually to the sensual Marie-Laure. When someone asked her "Does Charles like men or women?" she replied sourly, "He prefers flowers." Men appealed to him almost as much, and after finding him in bed with his personal trainer, his new wife felt free to take a succession of lovers.

Outrageous behavior became her trademark. To a reporter sent to profile her for the *New Yorker*, she remarked conversationally, "Men who love Proust have short penises, don't you think?"—a gibe at Charles, who inspired a character in *A La Recherche du Temps Perdu*. When one of her former lovers visited their Paris mansion with a fiancée of whom

she disapproved, she left the room, only to return a few moments later in the nude. Posing in the doorway, she said, "I wanted to remind you what a *real* French woman looks like."

Despite their sexual incompatibility, the Noailles were devoted to one another and to the cause of modern art. They bought numerous works by new artists and commissioned others. As André Breton, leader of the Surrealists, remarked, his group "fed from the hand of the Noailles."

Deciding to build a holiday home on the site above Hyères, they approached Mies van der Rohe, the most innovative architect of the day. After he told them he was too busy to bother with the "interesting little house" they wanted, Marie-Laure bypassed his main competitor, the Swiss Le Corbusier, because of his frosty manner, and chose instead radical young French architect Robert Mallet-Stevens.

Mallet-Stevens' devotion to the geometric rigidity of Cubism alarmed Charles. "I could never support a house that was just an architectural exercise," he warned him. "I look for an infinitely practical and simple house, where everything would be organized solely from point of view of utility."

But Marie-Laure overruled her husband. With her encouragement, Mallet-Stevens created a villa closer to a piece of sculpture than a home. Built of reinforced concrete, it featured a Cubist garden and an indoor swimming pool, with a gym (and Charles's lover as instructor). Since the house would

mainly be used as a summer retreat, twenty-five of the forty rooms were cell-like bedrooms, each with a minuscule terrace and Mediterranean view.

From the moment it was completed in 1925, Villa Noailles impressed visitors as they drove up the hill from Hyères but dismayed them once they got inside. American art critic James Lord complained, "A large salon had no windows but was lighted from above by a bizarre Cubist skylight which occupied almost all the ceiling, adding to the sense of existing outside time in a stranded ocean liner." Painter Jean Hugo remembered "innumerable rooms, rectilinear, unicolored. Like the blocks of a child's game tumbling one into the other, forming a strangely obscure labyrinth in which guests constantly lost their way."

Artworks filled the villa: furniture in chromed steel tube and leather by Le Corbusier and Marcel Breuer, fabrics by Raoul Dufy, sculptures by Brancusi and Giacometti, paintings by Mondrian. To many, it seemed less a home than a museum.

Each year, Charles commissioned an experimental short film for Marie-Laure's birthday. In 1929, the choice fell on two young Spaniards, Salvador Dali and Luis Buñuel, who had made their reputations the year before with a Surrealist short *Un Chien Andalou—An Andalusian Dog*. Charles owned a number of Dali's canvases and urged him to apply their inventiveness to the film.

At the end of December 1929, a nervous twenty-

nine-year-old Buñuel stepped off the train at Hyères. Although the Noailles had been supporting him for almost a year, he had no script and little idea what the film would be about beyond a protest at the way religious repression stifled sexual passion. The finale, inspired by the Marquis de Sade's *120 Days of Sodom*, would show its sated perverts emerging from their castle after weeks of depravity—except that the Duke de Blangis, their host, had been transformed into Jesus Christ.

A visit to Dali in Spain produced only a page of scribbled sketches. One showed a man devouring a woman's hand. In another, a cow reclined on a double bed. Dali didn't have the patience to think about how these ideas could be achieved on film. Painting was easier, and more profitable.

The Vicomte's invitation to Buñuel to spend the holidays at Hyères had all the signs of a summons. "I hope you'll do a gymnastics workout with me every morning," Charles wrote, concluding "I'm not hopeful about the athleticism of the others in the group." When he arrived, Buñuel, an amateur boxer and proud of his physique, soon saw why. Fellow guests included composer Georges Auric, designer Christian Bérard, art historian and collector Georges-Henri Rivière, manager and lover of music-hall star Josephine Baker, and Jean Cocteau, accompanied by young writer Jean Desbordes. Though Marie-Laure insisted everyone wear a striped swimming costume and shorts designed to conform to the villa's Cubist severity, nobody did much swimming nor indulged in morning

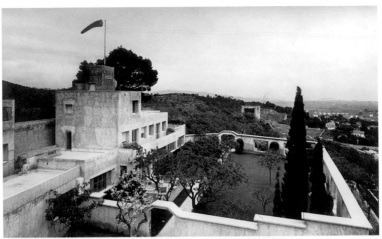

Clockwise from top: Villa Noailles, 1929; Georges Auric, Marie-Laure de Noailles, and Luis Buñuel at the Villa, 1930; Jean Cocteau, André Gide, Charles and Marie-Laure de Noailles and Georges Auric at the Villa, 1930

calisthenics, since most stayed up all night smoking opium.

Buñuel, not himself a user, was disgusted by the stink of drug smoke and stale sweat that hung round the villa's bedrooms after a night of heavy smoking. Though morphine, cocaine and heroin provided a more intense sensation, French artists preferred opium. As pipe followed pipe, the world was transmuted into pure movement and form. Serious *opiomanes* traveled with their own pipes and supplies of the drug—even Cocteau, who had just undergone treatment to break a habit of sixty pipes a day.

Conscious that the film had to be completed by April, Buñuel exercised and swam each morning, then spent the day working on the screenplay. In the evening, he read his day's work to the Noailles, who were enthusiastic, and apparently unconcerned that it attacked the pious and conservative society to which they belonged. Marie-Laure suggested that, since Villa Noailles was the avatar of a new Golden Age, he should call the film *L'Age D'Or*.

Charles authorized Buñuel to begin shooting in April. Once Dali heard that his partner had completed the script without him, he claimed angrily that it was "a caricature and a betrayal of the idea," and refused to participate. A rift opened between the friends that would widen with the years. Shortly after filming ended, Buñuel and his star Lya Lys were offered contracts to work in Hollywood. He wasn't around for the scandal that blew up once

L'Age d'Or opened at Montmartre's Studio 28. The extreme right-wing League of Patriots, deciding, erroneously, that the film was both foreign and Communist, wrecked the cinema. *Le Figaro* announced that, by showing the film, "our Country, the Family and Religion are here dragged in the mud." The censors, who had already passed it, reversed their decision, to the fury of cinema owner Jean Mauclaire, who repeatedly mentioned the Noailles in the press, stressing their impeccable social credentials.

Belatedly, the Catholic Church called the film "essentially pernicious from the social, moral and religious points of view." Rumors circulated that the Vatican threatened to excommunicate Charles, but were prevented only by a large bribe from his mother. Almost worse in his eyes, the exclusive Jockey Club demanded his resignation. If he didn't resign, they said, every other member would be forced to do so.

Horrified that the project had rebounded so catastrophically, Charles wrote to Buñuel in Los Angeles, "The affair of *L'Age d'Or* has become gradually more venomous. We are obliged to avoid all scandal in future. *We must be forgotten.* Will you please ask Mauclaire *not to mention my name any more!*" He also warned Dali he would be buying no more of his paintings. Dali complained so bitterly that André Breton rearranged the letters of his name to create a new nickname—Avida Dollars—Hungry for Money.

Lya Lys in *L'Age D'Or*, 1930

The furor died down as quickly as it began, although *L'Age d'Or* remained banned in France until 1981. Charles never financed another film. While Marie-Laure continued to collect art, he retreated into horticulture. In 1947, his elaborately landscaped garden in the hills overlooking Grasse, watered by underground springs, was presented to the city.

Epilogue

Villa Noailles was extended in the 1930s but like many early buildings of reinforced concrete, deteriorated quickly. In 1973, after being closed for many years as unsafe, it was restored by the municipality of Hyères, to reopen in 1989 as an exhibition and conference center.

Charles de Noailles' gardens in Grasse (Avenue Guy-de-Maupassant, 06130 Grasse) are open on Friday afternoons from mid March to the end of May from 2 p.m. to 5 p.m..

PIERRE BONNARD: Always Afternoon

Alfred, Lord Tennyson, describing Ulysses and his weary crew stumbling on the island of the lotus eaters, wrote:

> *In the afternoon they came unto a land*
> *In which it seemed always afternoon.*
> *All round the coast the languid air did swoon,*
> *Breathing like one that hath a weary dream.*

Looking at the paintings of Pierre Bonnard, it's easy to see him as such a traveler, abandoning the strife of Paris to settle contentedly into lotus land—in his case a house called Le Bosquet in Le Cannet, on the hills behind Cannes. Concentrating on domestic life and with his wife Marthe as his model, he created a body of art notable for its quality of repose. His life, said a friend, was free from "the tensions and reversals of untoward circumstance. The tranquility

Marthe de Méligny in the bathtub, photo by Pierre Bonnard, c. 1908-10

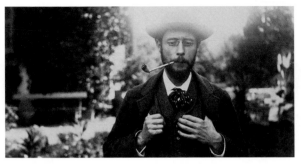

Pierre Bonnard in the garden in Le Grand-Lemps, c. 1906

of his painted world is not disturbed by the events of real life." Another wrote "It seems he painted from his happy childhood. His art is personal and intimate, and the twentieth century is absent."

Pierre Bonnard discovered the Riviera around 1904, when he was thirty-seven. Between 1922 and 1926, he rented three villas, before buying Le Bosquet in 1926, where he lived until his death in 1947.

Once Impressionism revived the practice of painting in the open air, numerous artists drifted to the Riviera from Paris, and, just as quickly, drifted back. The intense light and relentless primary colors demanded a readjustment many found impossible. Gauguin, perverse as always, headed for Polynesia in search of even brighter light and harsher hues, while Braque and Dufy, after struggling to adapt Cubism to the Mediterranean, found that the need to suppress color, the better to emphasize the geometrical structure of the object painted, made it essentially an urban style.

Each artist who remained on the Riviera found his own ways to deal with the near-white sky and a sea that reflected sunlight like a mirror. Some, like Matisse, embraced the semitropical gaudiness. Bonnard was no less enthusiastic. "Take your painting to Paris," he wrote, "and the blues become grey. In the light of the French south, everything is illuminated, and painting reaches the peak of its vibration."

It was not his way, however, to expose himself totally to that searing glare. Rather, he muted color, sheltering his subjects from the sun. Bonnard is a painter of the shade who realizes that shadows can be more real than the objects that make them. As Cézanne explained, the silhouettes cast by the Mediterranean sun may not only be black but also blue, red, brown and violet. Picasso shrewdly perceived that Bonnard's palette mixed a variety of primary colors into "a potpourri of indecision."

Bonnard was fortunate in never needing to fight for recognition. His talent was recognized from the start. Born to a wealthy family, he enjoyed an idyllic childhood. He had the money to enroll in the most prestigious of Paris's private art schools, the Académie Julian, where, with fellow students Edouard Vuillard, Henri Ibels and Maurice Denis, he formed *Les Nabis*—Hebrew for The Prophets.

Not that the Nabis were particularly prophetic. Apart from being Jewish, what united them was an upper-middle-class sense of certitude. Believing in their innate good taste, they selected the best from

other schools of art and incorporated it into their own practice. Because of his liking for Japanese woodblock prints, Bonnard became known as "The Nipponabi."

The Nabis accepted commissions for book illustration and even advertising, at which Bonnard again proved himself a master. His prizewinning 1889 design promoting French champagne inspired Henri de Toulouse-Lautrec to experiment with lithography and go on to produce his own famous posters.

Bonnard also designed furniture and textiles, painted screens and stage sets, and made puppets—activities that provided a bridge to the Arts and Crafts movement in Great Britain. He was quickly taken up by Ambroise Vollard, dealer for both Cézanne and Picasso. For Vollard, Bonnard illustrated a number of limited editions. In 1937, Vollard, going through his papers, came across the application form for a subscription edition of *Daphnis and Chloe* he had published with Bonnard illustrations. He sent it to the painter with a note—"What good fortune to find such a talented illustrator as Bonnard." Bonnard responded 'What good fortune to find such a patron as Vollard."

In 1893, Bonnard met sixteen-year-old Marthe de Méligny, who became his muse, model and wife. It suggests something of Bonnard's remoteness that it wasn't until their wedding that he learned her true name was Maria Boursin. His choice was reflected in his work, since, although pretty, with long legs and

France-Champagne poster, 1891 (Bonnard made the lithograph in 1889)

firm breasts, Marthe suffered from a skin disease, the symptoms of which could only be eased by bathing. Bonnard painted her repeatedly, often showing her lying in the bath or emerging from it.

For a time, Bonnard had a studio outside Paris, but beginning in 1904 he spent increasing amounts of time in the south, including St. Tropez, where the remnants of its Moorish history reminded him of *The Arabian Nights*. In 1910, it was while Bonnard was sharing a Paris studio with Vuillard and Denis that Russian collector Ivan Morozov commissioned him to create a triptych for the staircase of his Moscow mansion. Remembering St. Tropez, Bonnard responded with *The Mediterranean*. Typically for him, the three panels don't show the southern sun at its most intense. Instead, it depicts women and children sheltering from the midday

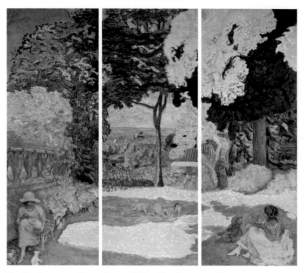

The Mediterranean, Pierre Bonnard, 1911, The Hermitage Museum

heat in the shade of tall trees while the sea glints in the distance.

The success of *The Mediterranean* encouraged Bonnard to move permanently to the south. The Fauve movement, Post-Impressionism and Cubism passed him by. Each year, his Paris gallery presented an exhibition that generated more than enough income for his modest needs. Until World War I, he traveled extensively, visiting Spain, Belgium, Holland, England, Italy, Germany, Algeria and Tunisia. In 1921, he made a trip to Rome with another woman, Renée Monchaty, with whom he'd fallen in love. When he decided to marry Marthe instead, Renée committed suicide.

Bonnard's great nephew recalled his unvarying daily ritual. "Before breakfast, he would drink a very large glass of cold water. Then he would go for a walk. One morning, we were walking along the canal, with this wonderful view of Le Cannet, with Cannes below and far away, in the blue distance, the mountains of L'Esterel. We came to an olive grove and he stopped and said to me, 'Look, Michel, look at those trees. I must have seen them a thousand times and they never said a thing to me. But last night it rained and they are shining with a brilliance I have never seen before.' He took a little piece of paper out of his pocket and he made a sketch, and later he painted a picture from it. That was how he worked. He painted nature always from memory, after his walks."

From these notebooks, Bonnard built up his compositions, sometimes working for years on a picture. At times he had a dozen or more canvases pinned to the plaster walls of the studio, in various degrees of completion. As props, he used objects that had stood on the shelves for years, and whose form and color he knew so intimately that he often worked from memory. When someone suggested he might introduce some fresh item into a composition, he demurred, explaining "I haven't lived with that long enough to paint it." When he occasionally tried something more innovative, such as a mural for the newly built Palais de Chaillot in Paris, venue for the 1937 Exposition Universelle, he felt it was less than his best work.

Bonnard took as much care with the preparation

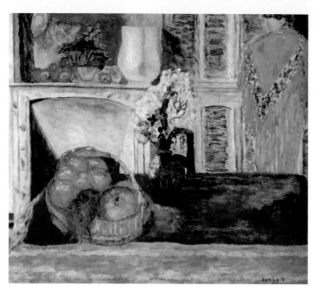

Corner of the Dining Room at Le Cannet, Pierre Bonnard, 1932, Centre Georges Pompidou, Paris

of his canvases and the application of pigment as with the furnishing of Le Bosquet. "I hope that my painting will survive without *craquelure*," he wrote. "I would like to arrive in front of the young painters of the year 2000 with wings of a butterfly." Even when a canvas left his studio, he didn't regard it as complete. Visiting a gallery with his friend Vuillard, he asked him to distract a guard while he made a small adjustment.

After the war, Bonnard spent time in the United States, though his travels had little influence on his work, nor did the war. His concentration on the same subjects, in particular the body of Marthe, impressed critics who were exasperated by the tendency of artists to embrace the latest vogue. By contrast with them, Bonnard's canvases seemed "meditative

masterpieces." After Marthe died in 1942, much of the spirit went out of Bonnard's life. He had lost his most absorbing subject.

Only at Le Bosquet did Bonnard feel completely at home. Over the years, he opened up the interior of the house, removing walls and shifting furniture until it became a world of its own within which he found numerous subjects to paint. Such works as *Corner of the Dining Room at Le Cannet* (1932), *The White Interior* (1932), *The Dessert* (1940) and *The French Window* (1932) celebrate the house and the objects within it. In particular he painted Marthe, often nude and either entering or emerging from the bath.

Bonnard's work absorbed him utterly. To him, the distinction between life and painting did not exist. As one critic wrote, "In the end, may it not be said that Bonnard lived at a remove from the world, sacrificing all to his passion for art?"

Epilogue

Le Bosquet at 16 boulevard Sadi Carnot in Le Cannet is preserved as a museum to Bonnard's work. Because of a conflict over inheritance, the house was closed up for decades and thus remained, unlike most artists' houses, uniquely untouched. For information see www.museebonnard.fr.

BRITONS BEHAVING BADLY: Somerset and all the Maughams

Only a few Anglo-Saxon writers settled permanently in France, and fewer still on the Riviera, most preferring Paris. To survive year-round in Nice or Antibes, one had to be sufficiently vain or misanthropic to enjoy one's own company during the winter months, or to be so preoccupied with work as to have no need of friends.

The most enduring of the Riviera's expatriate authors was William Somerset Maugham. A wealthy homosexual who spoke fluent French, he was perfectly suited to the exile life. Brought up in Paris, the son of a diplomat, he achieved success as both a novelist and playwright, and lived an eventful period as a secret agent during World War I. In 1926, he moved to France, where his sexuality attracted

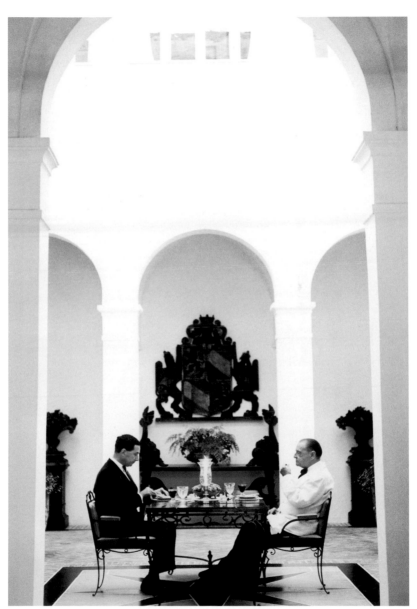

W. Somerset Maugham at lunch with his secretary, Alan Searle, at Villa Mauresque, Cap Ferrat, 1954

less attention. Buying a villa on Cap Ferrat, he lavishly renovated it, installing a swimming pool, a tennis court and the ultimate luxury for that harsh climate, extensive lawns, which had to be ripped up and replanted annually as sun and salt air killed the grass.

King Leopold II of Belgium originally built the house for his personal confessor, who decorated it in North African style. Maugham erased all sign of this, but its old title of The Moorish Villa—Villa Mauresque—remained. Partially to justify the name, Maugham had its gateposts decorated with a North African symbol to ward off the evil eye. Copied from some windows in his father's summer house at Suresnes outside Paris, it became his personal insignia, appearing on all his books.

During the 1930s, Maugham increasingly found new material in the Far East, in particular Singapore and Malaya, where Britons, having taken up what Rudyard Kipling called "the white man's burden" of subduing the locals, wrote of what he experienced, with melodramatic results. Plagued all his life with a stammer, he travelled with his lover, Gerald Haxton, who passed as his secretary, but was actually his pimp and spy. While Maugham drank pink gins with his hosts, Haxton socialized with the servants, returning at the end of the evening like an eager spaniel bearing juicy morsel of scandal.

In this way, Maugham gathered the gossip that informed such novels as *The Painted Veil* (1925) and *The Razor's Edge* (1944), both of which dabbled in

William Somerset Maugham

oriental mysticism, and a number of short stories
and dramas, in particular his play *The Letter* (1927),
later filmed, about interracial sex, infidelity and
murder among Malayan rubber planters.

Maugham entertained generously. House guests
included Winston Churchill, the Duke and Duchess
of Windsor, T. S. Eliot, H. G. Wells, Rudyard Kipling,
and even Virginia Woolf. The rich and titled vied for
invitations to the villa, where celebrities mingled
with disreputable but diverting companions. Nude
bathing in the ornate swimming pool was permitted,
even encouraged, and the rambling villa gave plenty
of opportunities for sexual misbehavior. Servants
were puzzled by the number of wet towels in the
rooms of *James Bond* author Ian Fleming until
they discovered he used them to whip his wife. Noël
Coward, a frequent visitor, paid tribute to these
uninhibited house parties when, in composing new
lyrics to Cole Porter's *Let's Do It*, he wrote:

Famous writers in swarms do it.
Somerset and all the Maughams do it.

This idyll was interrupted by World War II. Initially assuming hostilities would be averted at the last moment, Maugham invited friends to spend the summer of 1939 at the villa, particularly since the first Cannes Film Festival was scheduled to end the season. That a war was likely became evident as the army fortified Cap Ferrat, regarded as particularly vulnerable because of the nearby lighthouse. When most of Maugham's Italian servants decamped, and orders came from Paris for all private yachts to leave Villefranche, Maugham took the hint. Placing his artworks in storage, he and Haxton loaded up his yacht, the *Sara*, and sailed farther down the coast, to Bandol. When, after a few weeks, no hostilities broke out, they returned to Cap Ferrat, to find the house untouched.

Maugham volunteered his services to the British government, initially without response. "I was like a performing dog in a circus," he complained, "whose tricks the public would probably like, but who somehow couldn't be quite fitted into the program." At last, the Intelligence Service, recalling his activities during World War I, asked him to circulate among his French friends in high places and send back his assessment of France's readiness for a German invasion. As cover, he wrote pieces for British papers about the preparations for war. Although his articles were optimistic, he privately reported that morale in the French armed forces was low, discipline casual, and the attitude to their British allies distrustful.

All this became academic as the "phoney war" ended and Italians moved up the coast to occupy the Riviera. Maugham, along with other expatriates, abandoned their homes for the second time. Crammed onto a collier, the *Saltergate*, with 500 other refugees in a space meant for the thirty-eight-man crew, Maugham arrived finally in London, then fled to the United States, where he spent the rest of the war. Gerald Haxton made his way there independently, only to die of tuberculosis in 1944.

Maugham returned to France to the Villa Mauresque to find the windows shattered, his wine cellar plundered, the floor of his swimming pool fractured, and an unexploded British shell lodged in his bedroom. The worst damage had been inflicted by his French neighbors, who looted his crockery and cutlery and stole even the bolts from the bathroom doors.

Consoling himself with other companions for the loss of Haxton, Maugham took up his former life as a literary lion. Film versions of his novels *The Razor's Edge* (1946) and *The Moon and Sixpence* (1942) made him even richer. He began buying paintings again, assembling a collection of Impressionists, including works by Matisse, Renoir, Pissarro, Bonnard, Monet and Utrillo. He also bought two Picassos. On hearing this, Jean Cocteau, surprised that the two men had never met, offered to introduce them. Nostalgic for the prewar days of well-bred Riviera leisure, Maugham asked "Does he play bridge?"

Clockwise from top: Movie posters of *The Painted Veil* (1934), *The Moon and Sixpence* (1942), and book cover of *The Razor's Edge* (1944), (first American edition)

Maugham's last years were marred by squabbles over his considerable fortune. Isolated in the Villa Mauresque, he was increasingly dominated by a new companion and lover, Alan Searle, who stirred up enmity between the writer and his family, apparently to increase his share of the author's bequest. No less rapacious was Robin Maugham, Somerset's nephew. Also an author, he wrote three potboiler memoirs of "Willie," including one called *Somerset and All the Maughams* (1966), as well as two volumes of autobiography with copious references to his uncle. His one work of note was *The Servant*, a 1948 novella in which an unscrupulous domestic dominates and corrupts his employer—exactly the process William Somerset Maugham endured as the sun went down on his superficially idyllic Riviera life.

Maugham died in Nice, aged ninety-one, in 1965. By then, his reputation had almost disappeared and with it his once wide circle of friends. When his publisher proposed a collection of congratulatory essays on the occasion of his eightieth birthday, so many former houseguests declined to contribute that the project was abandoned.

Other Anglo-Saxon writers to live on the Riviera included Aldous Huxley and Edith Wharton. Huxley lived at Sanary-sur-Mer for many years. He was visited there by D. H. Lawrence, who died of tuberculosis in nearby Vence, and also by Wharton, who bought the Castel Sainte-Claire in Hyères in 1927, creating a meticulously furnished house and a showpiece garden.

Edith Wharton at home in her villa, Castel Sainte-Claire, 1933

Guests of Wharton or Huxley seldom lingered. Wharton fidgeted if a guest took a book from her shelves or so much as dented a seat cushion. Huxley, though less fastidious, was a tireless worker, writing every day, even Sunday. When Charles and Marie-Laure de Noailles came to stay in 1930 while weathering the scandal over the Dali/Buñuel film *L'Âge d'Or*, he was glad to see them leave. "Tho' nice," he said," they have the rich persons' inability to conceive that other people have anything to do than eat lunches and teas in their houses."

Sanary-sur-Mer became even more trying for Huxley late in the 1930s when German literary refugees collected there, waiting to flee by ship to neutral Portugal, and then to the Americas or Palestine. They included Bertolt Brecht; Arnold Zweig; Thomas Mann and family; Martha and Lion Feuchtwanger; as well as Franz Werfel and his wife Alma, the widow of Gustav Mahler. As Ludwig Marcuse remarked, for a few months Sanary became "the capital of German literature." This was too much for Huxley. Unable to work in

peace, he gratefully accepted an invitation to write screenplays in Hollywood.

In the 1960s, more British and American writers fled south in search of peace and quiet. Novelist James Baldwin took a house in Vence. The author of *The Alexandria Quartet*, Lawrence Durrell, who had lived in many locations around the Mediterranean, as well as in Paris, settled in Sommieres, inland from the Riviera, and died there in 1990.

Actor Dirk Bogarde and his partner Anthony Forwood bought and restored a house in Grasse where Bogarde launched a late literary career with a series of memoirs and novels, the latter often autobiographical. *Voices in the Garden*, set in Villefranche-sur-Mer, describes the arrival by yacht of tyrannical film director Grotterosso, a character inspired by Luchino Visconti, who directed Bogarde in *Death in Venice* (1971) and *The Damned* (1969).

Epilogue

In Sanary-sur-Mer, a plaque marks the former site of Villa Huxley on l'Allée Thérèse. Edith Wharton's house in Hyères, Castel Sainte-Claire, which stands on rue Edith Wharton, is not open to the public, but the gardens on which she lavished so much attention can be visited every day.

Maugham's Villa Mauresque (not to be confused with the Hôtel Villa La Mauresque) remains a private home, standing on boulevard Somerset Maugham. Although the house is much altered, its gateposts still display the Moorish sign fending off the evil eye.

FRENCH RIVIERA SCENES

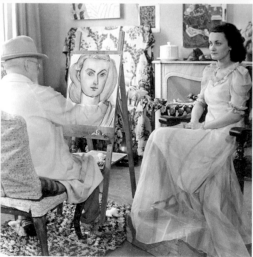

Clockwise from top left: Audrey Hepburn in Monaco for the movie *Monte Carlo Baby*, 1951; Queen Victoria (right) at breakfast in Nice, 1895; Brigitte Bardot in *And God Created Woman*, 1956; Lydia Delectorskaya and Matisse at villa Le Rêve in Vence 1946; F. Scott and Zelda Fitzgerald in Juan-les-Pin, 1926

Clockwise from top left : Diana Dors at the Cannes Film Festival, 1960; Jean Cocteau, Pablo Picasso, Igor Stravinsky and Olga Picasso in Antibes, 1926; The Duke and Duchess of Windsor in Cap d'Antibes, 1936; Cole Porter with Gerald Murphy's skull cap and Sara's pearls, 1923; Francoise Sagan in St. Tropez, 1956

PABLO PICASSO: In a Season of Calm Weather...

In 1959, fantasy writer Ray Bradbury published the short story *In a Season of Calm Weather*. It describes an enthusiast for Pablo Picasso who visits the Riviera in hopes of meeting him. Walking on the beach one evening, he does indeed run into the artist, out with his dog, but doesn't speak—simply watches in wonder as Picasso, using nothing but a small stick, idly scratches a riotous frieze of nymphs and satyrs in the wet sand. But his delight has a downside. With no way to preserve the work, the man must resign himself to letting the waves wipe it out. Back in his hotel, he sits at the window, listening. When his wife asks what he hears, he says "Just the tide, coming in."

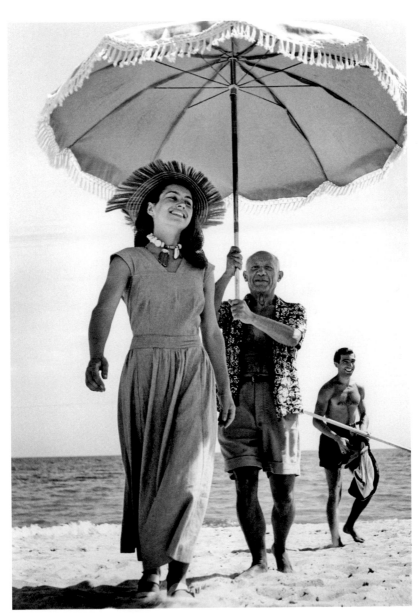

Pablo Picasso and Françoise Gilot at Golfe-Juan, August 1948

Bradbury focuses on one quality that separated Picasso from other artists—his prodigality. The image of him scratching a masterpiece in wet sand was no great stretch. Creativity oozed from every pore. He not only produced more original and adventurous work than any contemporary—a total of tens of thousands of items—but did so in almost every medium: oil on canvas, ink on paper, etching, ceramics, and lithography. Confronted by a table covered in soft clay pots, he could twist, mold, and pinch them into different forms—doves, fish, women—leaving them to be glazed and fired by assistants. Tin cans, wire and scrap metal, bent and soldered together, were transformed into a menagerie of animals. He sketched on menus, tablecloths, and matchbooks. He might pay a bar bill by scribbling a portrait or *corrida* scene on the verso. In 2010, an electrician produced a cache of 241 paintings which he claimed Picasso gave him in payment for house improvements.

It became a point of honor to let no artistic challenge go unanswered. Chilean artist Manuel Ortiz de Zárate, having fallen on hard times, took to Picasso his nest egg, an ingot of gold, in hopes he'd buy it. Picasso asked for a few days to consider. In that time, Picasso, according to writer Paul Bowles, "was feverishly studying the essentials of the goldsmith's craft, one of the few which he had until then neglected. He smelted the gold, made it into a small, rather Aztec-looking mask with features in relief, and engraved his signature on the back." When Ortiz returned, Picasso presented him with the mask, worth many times the value of the raw metal.

Picasso moved house as often as he changed companions. The key to his restlessness was women. "He loved women and used them in order to be creative," says his granddaughter Marina. Long-time mistress Françoise Gilot sarcastically compared him to legendary wife-murderer Bluebeard: she would not have been surprised, she said, to open a wardrobe in his home and find the bodies of her predecessors hanging there. With Marie-Thérèse Walter, Picasso spent more time in the Normandy resort of Dinard. With his first wife, Olga Khokhlova, and such companions as Dora Maar, his home was Paris, but with his last wife, Jacqueline Roque, and with Gilot, his preferred milieu was the Riviera.

Each move, like each woman, brought fresh inspiration. His earlier work, in particularly the Cubism he developed with Georges Braque, shows a metropolitan sophistication in its use of a city's detritus—newspapers, advertising signs, sheet music. However his ceramics, redolent of ancient Mediterranean trade, his images of the bullfight, the romping giantesses of his décor for the ballet *Le Train Bleu* (1924), his co-opting of Greek mythology in his use of the Minotaur myth to symbolize his own waning potency, and of Provençal whorehouses in *Les Demoiselles d'Avignon* (1907) to celebrate the carnality of bought sex—all these bear, as if seared into them, the imprint of a Mediterranean sun.

In 1936, Picasso rented a house in Mougins, a village built on the ruins of a Roman settlement in the hills behind Cannes. He was visited there by such artist friends as Picabia, Cocteau, Léger and Man Ray,

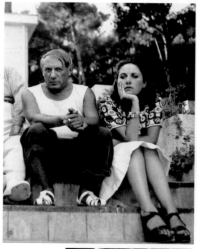

Picasso's muses, clockwise from top: Olga Khokhlova, 1919; Marie-Thérèse Walter, 1928; Lydia Sylvette David, 1954; Jacqueline Roque, 1955; Dora Maar, 1937

all of whom spent summers in the south, often at
the nearby homes of Marie-Laure and Charles de
Noailles in Hyères or at the Villa America of Gerald
and Sara Murphy in Antibes, where Picasso would
often join them.

When his Mougins landlord, ignorant of his fame,
protested his habit of painting on the walls, Picasso
found new working space in Antibes. In 1946, with
his newest mistress Françoise Gilot as assistant, he
decorated an entire floor of the Château Grimaldi—
today the Musée Picasso. In 1948 he moved with
Gilot to Vallauris, a Communist-governed town
in the hills above Cannes, and there he created
murals for a deconsecrated chapel disused since
the Revolution of 1789. Described optimistically as
a "Peace Chapel," the building and its belligerent
frescos channeled Picasso's personal turmoil into
a protest on behalf of the town and the Communist
party against the war in Korea. They are also an
atheist's wry comment on the two Catholic chapels
in nearby Vence, decorated by Matisse and Chagall.
The Peace Chapel is now a part of the National
Picasso Museum. Gilot left him, taking their two
children, in 1953—the only of his partners to do so.

In Vallauris, Picasso fell under the spell of yet
another woman in the spring of 1954. Nineteen-
year-old Lydia Sylvette David caught his eye when
she helped her furniture-designer boyfriend deliver
some chairs to Picasso's villa, La Galloise, in the
hills outside town. Long-necked, slim and blonde,
Sylvette wore her hair in bangs and a long ponytail
high on the back of her head, a look inspired by

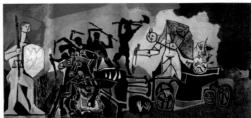
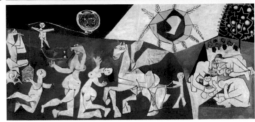

Peace Chapel and *La Guerre et la Paix* (*War and Peace*), 1952

ancient Greece by way of a recent Paris stage production of Jean Anouilh's *Antigone* (1944).

Picasso, captivated, asked her to sit for him, and began work on what became a series of sixty drawings, paintings, and sculptures. She insists she was too timid to pose nude or become his lover. Christoph Grunenberg, director of Germany's Kunsthalle Bremen, which has exhibited some of the series, suggests this could have fuelled Picasso's inspiration. "Maybe it was her resistance to be seduced by him that made him need to see her: because he didn't conquer her, he needed to conquer her on canvas and on paper and in sculpture." Denied her naked body, Picasso concentrated on externals; her ponytail, the innocent wide-eyed pout, even her then-fashionable hooded coat with large buttons down the front. Echoes of her would

continue to appear in his later work, including the fifty-foot-tall sculpture installed in Daley Plaza in the center of Chicago in 1967.

In 1955, Picasso moved to a tumbledown mansion above Cannes called La Californie. Built in 1920, it became his holiday home and a storehouse for both his own work and that given to him by others. After his death, more than 500 canvases, his personal archive, going back to his childhood in Spain, were removed from the villa. They became the basis of the collection now housed in the Musée Picasso in Paris.

It was at La Californie in 1956 that the artist encountered another twentieth-century icon, Brigitte Bardot. With her pout and high ponytail, the actress strikingly resembled a more knowing version of Sylvette David—no accident, says David, who claims Bardot and her director Roger Vadim copied her. "I only had one brief meeting with Brigitte Bardot, when we passed each other on the promenade at Cannes during the film festival of 1954. She was on Vadim's arm and I was on Picasso's, and of course we took a long look at each other and the men took a long look at us. The next time I saw her, she was no longer a brunette but had dyed her hair blonde to match mine, keeping the fashionable dark eyelashes. She had adopted the ponytail, but really it wasn't as stylish." Although photographer Jerome Brierre covered the meeting of Bardot and Picasso for *Life* magazine, Picasso never painted Bardot. In her version, she was too shy to ask. Others suggest she did offer, but Picasso, faithful to Sylvette, turned her down with a curt "I only have one model at a time."

La Californie was no luxury residence. Some rooms, including the kitchen, remained floored in earth, and animals, among them a goat, wandered in and out at will. Picasso himself slouched around in baggy t-shirts and shorts. He made no concessions to visitors, least of all to his grandchildren Marina and Pablito, who lived in poverty in Cannes with their grandmother, Olga. Their father Paulo, who, as a boy, had modeled for Picasso as a sad-eyed clown, lacked artistic talent. He preferred automobiles, and wanted to open a garage, but his father, embarrassed, made him his chauffeur instead. Humiliated, Paulo became an alcoholic, and died young.

When Marina and Pablito needed money, they were told to ask their grandfather. He often left them standing at the gate for hours, then sent his housekeeper to inform them that "the Master" was too busy to see them. Picasso only took an interest when Marina became a pretty adolescent.

In 1958, Picasso acquired the Château de Vauvenargues, in the countryside near Aix-en-Provence immortalized by Paul Cézanne. "I have just bought Cézanne's Mont Sainte-Victoire," he boasted to friends. Thinking he meant one of the artist's canvases of the mountain, they asked, "Which one?" "The *real* one!" Picasso snapped in exasperation.

The château's remote location and imposing architecture reminded Picasso of his birthplace in Spain. Intending to spend the rest of his life there, he installed a number of bronze figures on the terrace and transferred hundreds of paintings from

Pablo Picasso and Jean Cocteau at a bullfight in Vallauris, France, 1956

other houses. However, his last wife Jacqueline Roque found it too isolated and draughty, so after only two years they moved to Mas de Notre-Dame du Vie in Mougins, where he lived his last twelve years, and died in 1973. When the authorities at Mougins refused to let him be buried in the garden, he was interred at Vauvenargues.

While Picasso lived, Jacqueline had been his strict, indeed fanatical protector. Even after they married,

she continued to address him as "Master," and even "Soleil"—Sun. She barred many members of the family from the funeral, claiming he would not have wanted them there. They included Paloma and Claude, his children by Françoise Gilot, and former mistress Marie-Thérèse Walter. She also turned away Pablito and Marina.

Following Picasso's death, bad luck dogged the family. Shortly after the funeral, Pablito killed himself by drinking bleach. In later years, Jacqueline Roque, Marie-Thérèse Walter and Dora Maar also committed suicide. Picasso always refused to make a will, gleefully anticipating that his heirs would fight over his millions. He might have been surprised by the result. Backed by the fortune of her husband, American biologist Jonas Salk, Françoise Gilot forced a change in the law, permitting both legitimate and illegitimate children to share an inheritance. Her son Claude later became chief administrator of his father's legacy.

Ironically, La Californie, as part of Paulo's inheritance, passed to Marina, the grandchild Picasso once scorned. Renamed Pavillon de Flore, it has become a showcase. Among the works hanging there is his pensive portrait of the mentally unstable Olga. If guilt has a color, it is that of her dress in the painting, the greyish pink known as Ashes of Roses, emblematic of her troubled life, and, some might say, of the way Picasso consumed women in the fire of his genius.

Epilogue

La Californie is a private residence, situated at 18 avenue Coste-Belle. It is not open to the public.

Sited in the old Grimaldi chateau, the Picasso Museum, Antibes, devoted to Picasso and friends, opened in 1966 and can be visited year-round. As well as works by Picasso, it contains canvases and figures by Arman, Balthus, César, Dezeuze, Ernst, Gleizes, De Staël and Miro.

The Peace Chapel at Vallauris is open every day but Tuesday. Place de la Libération, 06220 Vallauris.

In 1969, *In a Season of Calm Weather* was filmed as *The Picasso Summer,* with Serge Bourguignon directing Albert Finney as a Picasso-obsessed architect and Yvette Mimieux as his long-suffering wife. Most of the film is ill-conceived animation of Picasso's work. Bourguignon left the project, which was completed in California, and never released in U.S. theaters.

"THE WALLS SPEAK FOR ME": Jean Cocteau and the Villa Santo-Sospir

Graphic artist, playwright, poet, novelist, film director—Jean Cocteau was too multi-talented for his own good. In a period characterized by commitment and specialization, his contemporaries scorned his failure to join some movement or embrace a creed. Cocteau felt himself to be above petty categorizations. He preferred to echo Oscar Wilde, who, on being asked by U.S. Customs if he had anything to declare, is said to have replied, "Only my genius."

Nothing about Cocteau was conventional, least of all his childhood. His father committed suicide when he was nine. He was raised by his maternal

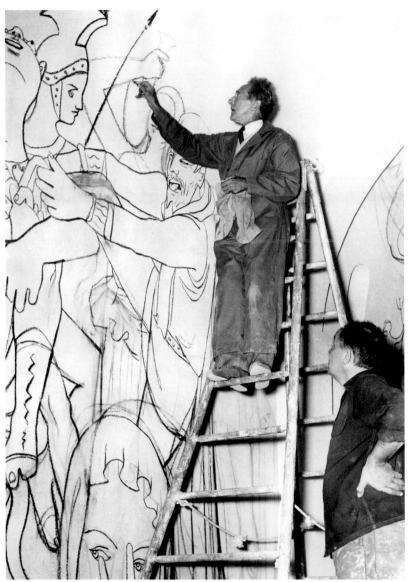

Jean Cocteau works on the mural of the life of St. Peter in St. Peter's Chapel, Villefranche. Painter Jean Paul Brusset watches, 1956

grandparents and an often absent mother, whom he believed to be an actress, perennially on tour—until, at twenty, he recognized her in photographs taken in a womens' prison. A kleptomaniac, she had been serving sentences for theft.

As a child, Cocteau contracted what he called "the red and gold sickness"—a love of theater. It proved incurable. Everything he touched took on the quality of a performance, even his service during World War I. With crossdressing socialite and dilettante Etienne de Beaumont, he joined a private ambulance unit put together by socialite Misia Sert, friend of Marcel Proust and Erik Satie, and lover of Coco Chanel. To transport the wounded, Sert co-opted the delivery vans of couturiers Jean Patou and Paul Poiret, which were standing idle since the army drafted the design and tailoring staff to make uniforms.

After leaving Sert's comic-opera enterprise—"I realized I was enjoying myself too much," he confessed—Cocteau responded to a challenge from Sergei Diaghilev to "Astonish me" by conceiving *Parade* (1917), a ballet set in a circus. He coaxed Satie into writing the music and persuaded Picasso to design it by turning up at his home dressed as a clown. He also wrote *Le Train Bleu* (1924) for Diaghilev, with costumes by Coco Chanel and décor again by Picasso. Turning to cinema, he directed the controversial short film *Le Sang d'un Poète* (*The Blood of Poet*, 1932) with money from Charles and Marie-Laure de Noailles. Once he began making feature films, *La Belle et la Bête* (*Beauty and the*

La Belle et la Bête (Beauty and the Beast), 1946

Beast, 1946) and *Orphée (Orpheus,* 1950), both starring his lover Jean Marais, became instant classics.

Attracted to athletic young working men, both as partners and models, Cocteau had been part of the group that waited in the wings of the Ballets Russe to sponge down a sweaty Nijinsky as he staggered off stage after a strenuous performance in such ballets as *La Spectre de la Rose* (1911). Later he rescued gay writer and habitual criminal Jean Genet from a potential life sentence by hiring one of France's best defense counsels to fight his case.

But while he appeared to know everyone, Cocteau remained essentially a loner. In François Truffaut's *La Nuit Americain (Day for Night,* 1973), the star, Jean-Pierre Aumont, dies in the midst of shooting. When the producer reflects that, spending his whole

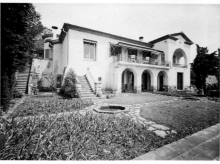

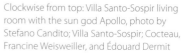
Clockwise from top: Villa Santo-Sospir living room with the sun god Apollo, photo by Stefano Candito; Villa Santo-Sospir; Cocteau, Francine Weisweiller, and Édouard Dermit

life on location, the actor was "at home nowhere," the director, played by Truffaut, disagrees. "He was at home *everywhere*. He died hurrying back to us, his friends."

The same could be said of Cocteau, who was seldom found at his apartment in Paris's Palais Royale, near that of his friend Colette. As winter came, he migrated south to the Riviera. An inveterate house guest, he was welcome in homes all along the Côte

d'Azur and left his mark in most of them. Sometimes it was only a sketch scribbled in a guest book, but given even a little encouragement he would break out his brushes and dash off a mural.

In 1950, money ran out midway through the filming of his novel *Les Enfants Terribles*. To raise more, director Jean-Pierre Melville suggested they find a wealthy patron with artistic pretensions on whom Cocteau could exercise his charm. The perfect choice, Francine Weisweiller, proved to be right under their noses, since they were already filming in her house, which was next door to the Paris mansion of Charles and Marie-Laure de Noailles on Place des États-Unis.

The Brazilian-born wife of an American oil millionaire, Weisweiller was spoiled, beautiful, rich, well-connected, and flattered by the attention of the multi-talented Cocteau. In taking him under her wing, she also inflicted a subtle revenge on her husband for his long-standing affair with actress Simone Simon. Francine persuaded her spouse to invest in *Les Enfants Terribles* (1950), and invited the unit to continue filming in Villa Santo-Sospir, their summer home in St. Jean-Cap-Ferrat. When shooting ended, Cocteau stayed on in the villa, ostensibly to rest. It was to be his Riviera home for more than ten years.

Summer at the villa became one long house party. Picasso regularly visited, along with Greta Garbo and Marlene Dietrich. Though Weisweiller's Bentley was always waiting in the garage and her

yacht *Orphée II* was moored nearby, she, Cocteau, his adopted son Édouard Dermit and their friends seldom left the house. Why bother, when she so generously indulged his tastes for opium and attractive young men? According to art historian John Richardson, the group was "bound together by mutual admiration—a sort of collective narcissism."

Francine took over management of Cocteau's career. Editions du Rocher, the press she co-owned with her brother, became his publisher. She was also instrumental in getting him elected as one of the forty "immortals" of the Académie Française, the ultimate honor for French intellectuals. Some members of this staid group found her lobbying offensive. When it admitted Cocteau in 1955, novelist François Mauriac wrote dryly "He did not stumble into our assembly dazed. He has had his eye fixed on the door for quite some time, waiting for it to open a crack so that he could slip in."

Cocteau repaid his debt to Weisweiller with art, creating tapestries, ceramics and mosaics for her homes. When she suggested the fireplace at Santo-Sospir needed brightening up, he surrounded it with a mural showing figures from Greek mythology. His two-dimensional style, something like cartooning— he called it "tattooing"—lent itself to wall painting, while his sexual inclination towards young sailors with Grecian profiles provided plenty of fuel for his imagination.

Above the fireplace, he painted a full-face black, gold and yellow image of the sun god Apollo, flanked by

two giant Priests of the Sun, modelled by fishermen from nearby Villefranche-sur-Mer, the little fishing town he had first discovered in 1924, at the time of *Le Train Bleu*. Inspired, he went on to decorate the entire house, including the furniture. "He said that he found the silence of the walls terrible," recalled Weisweiller's daughter Carole. "He learned from Matisse that once you paint one wall, the other three look bare." The work took six months. Later he remarked, "At Santo-Sospir, I'm most myself, and the walls speak for me."

Francine found him more commissions. In 1957, he decorated the dockside chapel of Saint Peter in Villefranche. Local fishermen again posed for the scenes from the life of Peter, Christ's "fisher of men." Picasso was polite about the result, but as Carole Weisweiller acknowledged, "The only work that interested Picasso was his own."

The same year, Francine negotiated a deal with the town of Menton for Cocteau to decorate the *salle des mariages* in the town hall. Since he found the room "rather unsympathetic," he decided, he explained, "to adapt the style of the turn of the century on the Riviera, with its villas, mostly now gone, interspersed with bunches of iris, seaweed and heads of waving hair." Before he was done, he had not only painted the walls and ceiling but redesigned the furniture, the lamps, the curtains, and added some incongruous touches of his own, including a few panther-skin rugs. In his spare time, he also created a small museum in the Bastion, a seventeenth-century fort built into the town's sea wall. Local pebbles made

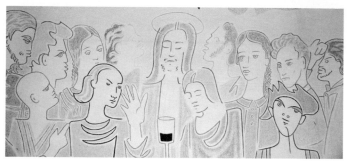
The Last Supper at the chapel of Notre Dame de Jérusalem

up a mosaic floor and the stone walls were hung with tapestries in medieval style.

No matter how great the charm of a house guest, most eventually wear out their welcome. Cocteau's relationship with Weisweiller soured in 1963, when she took a lover of whom he didn't approve. Cocteau moved to Villefranche. Despite efforts by Jean Marais to repair their friendship, they were never reconciled.

Before his death in 1963, Cocteau accepted one more mural project, but didn't live to finish it. Financed by Nicoise banker Jean Martinon, the chapel of Notre Dame de Jérusalem in the hills above Fréjus was to have been the centerpiece of an artists' colony. Cocteau planned the octagonal building with architect Jean Triquenot and executed some of the decoration, notably a *Last Supper* at which the apostles are portraits of Coco Chanel; Jean Marais; poet Max Jacob; novelist Raymond Radiguet, Cocteau's one-time lover; Francine and Carole Weisweiller; and Cocteau himself. After his death, Édouard Dermit and ceramicist Roger Pelissier completed the decoration—poorly, in the

general opinion. As neither Martinon, a freemason, nor Cocteau was conventionally Catholic, the chapel employs often obscure imagery, some of it related to the Crusades and the Order of the Knights and Dames of the Holy Sepulchre of Jérusalem.

After her break with Cocteau, Francine Weisweiller, in poor health and with much of her fortune gone, became a recluse, barricaded like a sleeping beauty behind the umbrella pines and banks of crimson hibiscus that shielded the villa from the outside world. She died there in 2004. Four years later, it became a national monument. Cocteau is buried in the Paris satellite town of Milly-le-Roi but his spirit speaks to us from the walls of Santo-Sospir.

Epilogue

The Villa Santo-Sospir is a historic monument, and open for tours, though by reservation only. A twenty-minute film of the villa, which Cocteau edited together from home-movie footage, can be viewed on YouTube.

The Chapel Sainte Pierre in Villefranche-sur-Mer, for which Cocteau painted murals, remains the church of fishermen of Villefranche, and is open to visitors, as is the Jerusalem Chapel at La Tour de Mare, outside Fréjus.

Menton has several Cocteau sites, including the *salle des mariages* in the town hall, the Bastion museum, and, since 2006, The Jean Cocteau Museum, the world's largest collection of his work, assembled by millionaire jeweler Séverin Wunderman. To house the donation of more than two thousand paintings, drawings, manuscripts, films and documents, the city commissioned a strikingly modern building from architect Rudy Ricciotti.

MARC CHAGALL: An Angel in His Head

As he looked back on his long, productive and highly eventful life, marred by revolution and war, Marc Chagall might have thought it ironic that his art, essentially mystical and religious, would reach its widest audience through a Broadway musical.

For the 1963 show *Fiddler on the Roof*, scenarist Joseph Stein, lyricist Sheldon Harnick and composer Jerry Bock adapted Sholem Aleichem's stories of life during 1905 in a Jewish village in Russia. The title came from a remark by Tevye the Dairyman, its philosophizing central character. "Without our traditions," he explains, "our lives would be as shaky as a fiddler on the roof."

Chagall, who designed sets for some Aleichem plays for the Moscow State Yiddish Theater, created a wall panel on this theme in 1920. Called simply

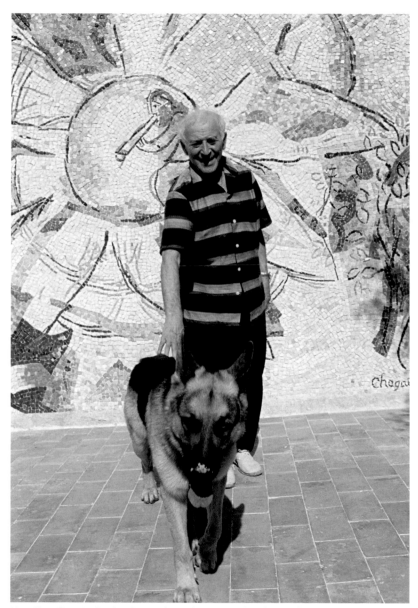

Marc Chagall petting his dog, Pasci, in front of a mosaic in his villa, La Colline. Saint-Paul de Vence, September 1967

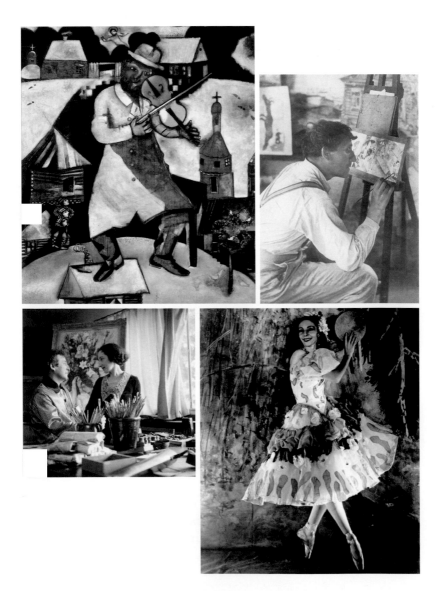

Clockwise from top left: *The Fiddler*, Marc Chagall, 1912-1913, Stedelijk Museum Amsterdam; Marc Chagall at the Jewish Theatre, Moscow, 1919-1920; Marc Chagall and Bella in Paris, 1938-1939; Markova as *Aleko*'s gypsy Zemphira, costume design by Marc Chagall

The Fiddler, it showed a violinist balanced on one foot on a tiny house. Since the artist carried a copy when he left Russia for the west in 1922, the image obviously represented an important truth to him. Nevertheless, it surprised the seventy-seven-year-old Chagall when choreographer/director Jerome Robbins approached him to design the Broadway production.

In some respects, it was not so great a stretch. In Moscow, Chagall studied with Diaghilev's costumier Léon Bakst and created the décor for some plays. Exiled in New York during World War II, he created sets and costumes for *Aleko*, a ballet by another graduate of Diaghilev's company, Léonid Massine, as well as a famous 1945 production of Stravinsky's *The Firebird* for the New York City Ballet. A critic wrote "his enchanted forest has an iridescent glow that matches the colors in the music, and there has never been anything to equal the impact of the vibrant ruby reds in the throne room when, to the spaced hymnlike chords of the finale, the curtain rushes up and reveals them."

In 1963, however, Chagall was preoccupied with a major project; a new ceiling for the Paris Opera. He responded to Robbins with a terse telegram *Regrette Trop Occupé*—Sorry Too Busy. Nevertheless his image of the rooftop violinist remained central to *Fiddler on the Roof*, to his irritation. He wrote to a friend, "'I am amazed that Mr. Robbins, who is a great artist, can consider using my drawings against my will."

Chagall led as unsteady a life as that fiddler. Born Moise Shagal in the mainly Jewish town of Vitebsk, now part of Belarus, he changed his name to Mark Shagalov when he moved to Moscow and to Marc Chagall when he travelled on to France. His arrival in Paris in 1910 coincided with the vogue for Cubism, a style in which he experimented, but without enthusiasm, preferring the more free and colorful work of the Post-Impressionists and the group calling itself *Les Fauves*—The Wild Beasts.

Folk art and the traditions of his Jewish upbringing would always dominate his work. Even those who found his painting naïve and mocked his anatomically dubious animals acknowledged the emotion embodied in his vision of lovers floating ecstatically hand in hand over the roofs of a Russian village or soaring towards a beneficent and welcoming God. "I don't know where he gets those images," said Picasso. "He must have an angel in his head."

It was because the light and color adapted so well to his style that Chagall found the Riviera revelatory. "There, in the south," he wrote, "for the first time in my life, I saw that rich greenness—the like of which I had never seen in my own country." The fecundity of Mediterranean vegetation and the vivid azure of the sea would permeate his work, even when his subject matter was rural Russia. A donkey might be as green as cactus, a cow the crimson of hibiscus, and the sky through which his lovers flew as profoundly blue as the Mediterranean. Even Picasso, not over-generous with praise of his contemporaries, said in the 1950s

"When Matisse dies, Chagall will be the only painter left who understands what color is. His canvases are really painted, not just tossed together. Some of the last things he's done in Vence convince me that there's never been anybody since Renoir who has the feeling for light that Chagall has."

After Paris, Chagall moved to Germany. In Berlin, he mastered the techniques of etching, lithography, and stained glass, and designed both décor and costumes for the theater. Returning to Vitebsk in 1914, he intended only to stay long enough to marry his fiancée Bella Rosenfeld before returning to France. But World War I broke out in August, the border with Germany was closed, and Chagall, with Bella and their child, were trapped in Russia, first by the war, then by the 1917 revolution.

Arriving in Paris with his family in 1923, Chagall found it more receptive to his work. Post-Impressionism had created a vogue for richly colored canvases, and other Jewish emigres such as Chaim Soutine were making a reputation with their bold images. In 1925, Chagall, sharing studio space with Soutine, saw blood oozing under the door and ran through the building shouting "Soutine has been murdered!" In fact his colleague had just purchased an entire beef carcass and was painting it, indifferent to the blood and stench.

Influential dealer Ambroise Vollard, who also represented Renoir, Cézanne, and, later, Picasso, commissioned a set of lithographs illustrating the Old Testament. Glad to escape from Paris for

awhile, Chagall spent two months in Palestine. On his return, he began work on 105 paintings in *gouache*—watercolor thickened with gum arabic— that would occupy him for the rest of his life. The fact that a gentile commissioned the series amused Chagall. As he wrote to a friend, "Can you imagine a Jewish publisher who could dare to make individual volumes of the Bible with my engravings, as Vollard has done? That's how he works. We Jews would just form a committee to decide who had the best scholarly credentials for the job."

In the 1930s, the Chagalls settled in Vichy, never expecting that, when Germany overran France in 1940, the quiet spa town at the center of France would become the seat of its puppet government. Even when French police began to round up Jews and ship them to Germany for extermination, Chagall believed he could escape notice. He moved to Gordes in a remote corner of Provence, hoping simply to be left alone.

Less optimistic friends appealed to Alfred Barr at the Museum of Modern Art in New York to place him on the list of artists whose welfare was of international concern. With the help of Quaker activist Varian Fry, who provided numerous Jewish artists with forged U.S. visas and smuggled them to the Americas or Palestine, the Chagalls found safety in the United States.

Though he found plenty of friends among New York's French-speaking emigres, Chagall's time in America was blighted by the death of his wife in

Palais Garnier ceiling

1944. When he returned to France in 1948, his work had become more introspective, and preoccupied with religious imagery. Many of France's great churches, in particular their stained glass windows, were damaged during the war. Matisse and Chagall became the most important artists working to restore them. Over the next forty years, often championed by de Gaulle's Minister for Culture, André Malraux, and funded by the Dominican order of monks, Chagall created windows, mosaics and murals for numerous religious buildings.

Among his secular work were stained glass windows for the United Nations headquarters in New York and a controversial, not to say incongruous new ceiling for the central cupola of the Paris Opera, unveiled in 1964. Commenting on this commission, Janet Flanner wrote in the *New Yorker* "What opera-goers fear from Chagall is something characteristically recognizable—a green-faced violinist, perhaps, or donkeys floating in the air." She was not far wrong. Chagall's designs included a violin-playing angel, ballerinas, and the Eiffel Tower.

Saint-Paul de Vence, c. 1885

Increasingly, Chagall gravitated to the Riviera and to biblical themes. Chagall moved to Vence in 1950, where he met his wife-to-be Valentina, known as "Vava," in April 1952. They were married on July 12, 1952. He began work on seventeen large canvases of the Old Testament, based on the Vollard *gouaches*. He intended them for the Calvary Chapel, attached to the Dominicans' Vence priory, then in disrepair, but once it became clear that damp might threaten the paintings, he withdrew.

While he worked on the series between 1958 and 1966, Chagall also created a mosaic, *Moses in the Bulrushes,* for the baptistery of Vence Cathedral. In the process he decided the Bible was too universal a book for his images to be confined to a Catholic building. The creation of Israel and a resurgence in Judaism reminded him of his cultural roots in the culture of Vitebsk, all the more vivid since most of

the town was destroyed during the war. Of 240,000 Jewish inhabitants, only 118 survived

Chagall offered his Bible paintings to the French state, with the proviso that they be displayed in a nondenominational setting. They became the basis of the collection in the Musée National Marc Chagall in Nice, which he insisted be called the National Museum of the Biblical Message.

In 1966, aged eighty, Chagall settled in the pine woods outside Saint-Paul, a village above an increasingly commercialized Vence. He built a large house, *La Colline*—The Hill, on the far side of the hill from his friends Aimé and Marguerite Maeght who had made their home, now the Fondation Maeght, a museum of modern sculpture. He contributed a number of pieces to their collection, including a panoramic canvas, *La Vie*—Life, and the large mosaic, *Les Amoureux—The Lovers*—which is among the first things visitors see on entering.

With the support of Andre Malraux, the Museum of the Biblical Message opened in 1973. Chagall had given detailed instructions to the architect, André Hermant, that the building should not appear like a museum but, rather, a house. In his speech at its inauguration, he said "I wanted to leave [the paintings] in this house so that men can try to find some peace, a certain spirituality, a religious sense, a meaning in life."

Hermant responded with a reticent, almost deferential design of low buildings surrounded

by greenery and water. Determinedly hands-on, Chagall dictated the form of the gardens, designed by Henri Fish, and created the stained glass and mosaics. Once it was completed, he donated his preliminary sketches for the Biblical series, and after his death the museum acquired the original *gouaches* with which the project began.

Chagall died on March 28, 1985, aged ninety-eight. At the insistence of Vava, his wife, who had, without his knowledge, converted to Catholicism, he was buried in the Catholic cemetery of St. Paul de Vence. It was only when Ida, his daughter by his first marriage, appealed for someone among the mourners to do so that a stranger stepped forward to recite Kaddish, the Jewish prayer for the dead.

Though Chagall is buried in France, his heart never truly left the Belarus of his childhood. In 1937, he wrote a long autobiographical poem, *My Distant Home*. It began:

> *It rings in me—*
> *The distant city,*
> *The white churches,*
> *The synagogues.*
> *The door*
> *Is open. The sky blooms,*
> *Life flies on and on.*

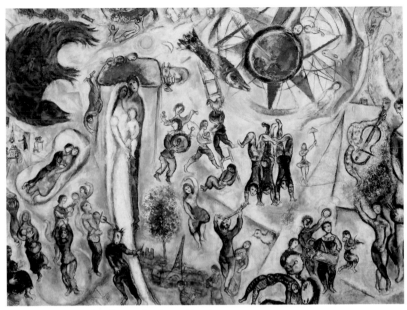

La Vie (detail), Marc Chagall, 1964, Fondation Maeght

Epilogue

In the cemetery of Saint-Paul de Vence, Chagall's grave occupies a plot donated by the then-mayor of the town. Crosses and other Catholic symbols that surrounded it have since been relocated. Following a Jewish tradition, many visitors place a small pebble on the simple slab.

AND ST. TROPEZ WAS CREATED: The Rise and Further Rise of Brigitte Bardot

As the cinema deserves some credit for transforming the fishing town of St. Tropez into an international center of conspicuous consumption, it's appropriate that the life of the saint after whom the town was named should be as improbable as a movie.

According to legend, Torpes of Pisa was a centurion guarding the Roman emperor Nero during the first century A.D. When, during one of Nero's rants about the gods, Torpes revealed his Christian faith, he was decapitated, his head tossed in the River Arno, but retrieved and made into an object of veneration. His body was set adrift in a leaky boat, along with a

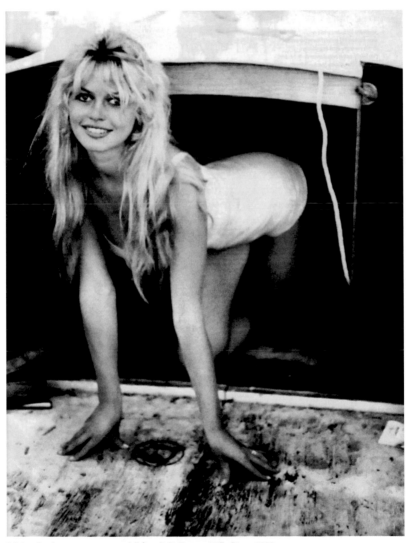

Brigitte Bardot at *quatre pattes* (all fours), St. Tropez, Willy Rizzo, 1958

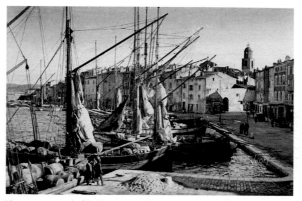

Vintage postcard of St. Tropez, c. 1920

cock and a dog, which were expected to devour it. By tradition, the boat drifted across the Mediterranean into the Golfe de Lion at the western end of the French Riviera and, driven by the north winds that make the area so disagreeable in the winter, beached near a fishing village. Finding the body miraculously untouched by decomposition or by its fellow passengers, the town promptly adopted his name, or the Provençal equivalent, Tropez.

Initially a Roman bastion against Muslim invasion from Africa, St. Tropez was seized by the Saracens, the Spanish and a succession of pirate warlords until the Italians installed some Genoese families and relieved them of taxes in return for defending it. Various conquerors fortified four tiny islands just off the coast: Porquerolles, Port-Cros, Île de Bagaud and Île du Levant, known collectively as the Iles d'Hyères or sometimes les Iles d'Or—The Islands of Gold. By the nineteenth century, St.

Tropez had settled into sleepy mediocrity. Bypassed by both the railway and the new main roads, it became mainly a retirement spot for old sailors. Even fishing languished. With no market for their catch, fishermen caught just enough to feed the town. The sole local industry existed on the offshore islands, where the government established a prison for young offenders. A few authors, including Leo Tolstoy and André Gide spent time in the sleepy town, relishing their isolation.

When Guy de Maupassant called at St. Tropez in 1887, he found that a narrow road over the Alpes Maritimes was the sole land route to northern France. To visit other ports along the Riviera such as Hyères, Cannes or Nice, an old pleasure launch offered risky transport across an often turbulent sea. But Maupassant savored the remoteness that had preserved evidence of the town's tangled past. He wrote of "Moorish houses with arcades, narrow windows, and inner courtyards, wherein tall palm trees have grown up and are now higher than the roofs."

Paul Signac, a keen sailor as well as a follower of Pointillist artist Georges Seurat, was driven into the port by the notoriously unreliable weather and so taken with the place that he bought a house there in 1892. His paintings glamorized the town. Ochre buildings and a harbor filled with fishing boats, their red and yellow sails rigged in North African fashion, suggest Algiers rather than a dowdy working port. Pierre Bonnard paid a visit in September 1910, and wrote to his mother that the port seemed like

St-Tropez, Le Quai, Paul Signac, 1899

something out of *The Arabian Nights*. He painted
a series of studies, including the olive trees and
oaks of the nearby hillsides and one sketch of a
dark-haired girl with a huge blue parrot. All would
be incorporated into *The Mediterranean*, a triptych
now in the Hermitage Museum in St. Petersburg.

Signac lured his friends from Paris by opening a
Salon des Independants. Henri Matisse and André
Derain were among his first catches, the former so
impressed that he used its beach to paint one of his
most sensual nude studies, *Luxe, Calme et Volupté*.
Raoul Dufy, Maurice de Vlaminck and Kees van
Dongen followed. André Dunoyer de Segonzac first
visited the town in 1908, and in 1925 bought a villa.
Less impressed with the color and exoticism of the

area, he painted the coast in the off-season when the Mistral wind whipped up the sea and turned the blue skies grey.

After Charles and Marie-Laure de Noailles began building their villa in Hyères in 1923, more creative people moved there, including composer Georges Auric, who had been their regular guest, although when the writer Colette bought a house about a mile outside St. Tropez in 1925, she and her husband Maurice Goudeket were the district's sole "foreigners." They found the local society decidedly unsophisticated. "In the evenings," wrote Goudeket, "in the genuine bars, the young people of the country would dance to the music of mechanical pianos, the boys with each other and the girls with each other."

St. Tropez first became a tourist area after 1931, when two doctors, Gaston and André Durville, acquired a sliver of Île du Levant, and established a nudist village, Héliopolis, the first in Europe. It was soon joined by another at nearby Cap d'Agde. During the 1950s, tourism increased. Backpackers, campers, and people on bicycle or boating holidays predominated among the trickle of visitors. Many came to visit the nudist beaches. Over the years, both naturist colonies developed into resorts with small hotels, restaurants and shops to serve the tourist invasion that could swell their summertime population to 100,000.

A resort that was both bohemian and exotic appealed to Paris sophisticates looking for an off-

beat holiday, and many St. Germain intellectuals, including novelist Boris Vian, and philosophers Jean-Paul Sartre and Simone de Beauvoir were soon seen in its cafes, which earned it the title "The Montparnasse of the Mediterranean." In 1951, American composer Ned Rorem, visiting Marie-Laure de Noailles in Hyères, dismissed the town itself as "distasteful" but was impressed that Surrealist poet Paul Éluard and his wife spent their days sunbathing nude on Île du Levant.

As elsewhere along the Riviera, true popularity came to St. Tropez from the sea. Yachts putting into the harbor during the 1950s brought film people and the first celebrities: Orson Welles, Errol Flynn, even Greta Garbo. Their reports caught the attention of film producer Raoul Lévy and director Roger Vadim, who were attracted by its empty beaches, raffish reputation and long days of sunshine. In 1954, the precocious eighteen-year-old novelist Françoise Sagan published the best-selling *Bonjour Tristesse*, the story of a teenage girl coping with the sex life of her playboy father on the Riviera. Both the book and its writer put St. Tropez decisively on the map.

Cinemascope was revitalizing a moribund cinema but most wide-screen films were historic spectacles, of little interest to younger audiences, who dismissed them as *le cinéma de papa*—Daddy's movies. Vadim proposed a wide-screen color film about a subject teenagers did find absorbing—sex. To star, he proposed his twenty-one-year-old wife, Brigitte Bardot, whom he had discovered at fifteen modelling for *Elle* magazine. Long-legged,

wasp-waisted, with a mass of blonde hair and a provocative pout, Bardot was every adolescent male's fantasy. She also knew St. Tropez. Her parents had owned a house in the town and she'd spent vacations there.

Lévy and Vadim tailored a plot to exploit the location, the wide-screen format and Bardot's sex appeal. *Et Dieu…. Créa la Femme—And God Created Woman* (1956) focused on Juliette, a rebellious teenage orphan frustrated by provincial life. Acknowledging the importance to the Riviera of gambling and pleasure boats, Vadim included a shady character who docks his yacht in the harbor and announces he's buying land for a casino. Of the brothers who own his preferred location, only one wants to sell. Before the film is over, Juliette will have slept with both, married one of them, and vamped the speculator to his destruction.

Audaciously, Vadim opened the film with Bardot sprawled nude across the screen, improving her tan in the shelter of some bedsheets drying in the sun. Sheets figure prominently thereafter, particularly when she marries the younger and more retiring brother. Following the ceremony, she leads him straight to the bedroom, ignoring the wedding breakfast. Later, she descends, wrapped only in a sheet, gathers some snacks under the gaze of the scandalized guests, and returns upstairs.

French audiences were only modestly impressed by *Et Dieu…. Créa la Femme,* although once American distributors sanitized the title to *And Woman Was*

Created, it made $4 million internationally on its $300,000 budget. It didn't, however, inspire the rebirth of St. Tropez as a film location. Any producer wishing to shoot on the Riviera still preferred the Victorine Studios at Nice (which Vadim employed for his own interiors). Jean-Luc Godard used some locations along the nearby coast and on the island of Porquerolles for his 1963 *Pierrot le Fou*, but the best-known film to take place in the town itself was the 1964 *Le Gendarme de St. Tropez—The Troops of St. Tropez*, starring comedian Louis de Funes as an uptight policeman from the north charged with the hopeless task of discouraging nude bathing.

The rise of St. Tropez is due almost entirely to Bardot's involvement in the town, of which she became the greatest asset and most enthusiastic supporter. Asked why she liked the area, she (or her publicist) cited "the mulberry trees, the sheep grazing in the scrubland, the huge bougainvillea-smothered farmhouses of the winemakers, their vaulted cellars filled with barrels of maturing Provençal wine. Here, local people raised their poultry and kneaded their loaves, while fisherfolk in their *tartans*—small flat-bottomed skiffs with wide square russet-hued sails—returned with their nets full of the sea's bounty."

In 1958, she renovated a rundown property, La Madrague, on the dirt road along the coast to the Baie des Canoubieres, where parts of *Et Dieu... Créa la Femme* were shot. Later she also bought La Garrigue, a converted chapel in the hills behind the town where she maintained a cemetery for the cats

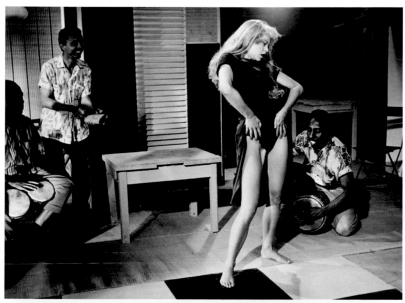

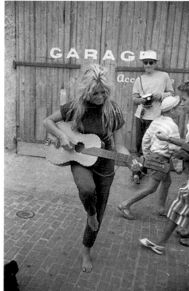

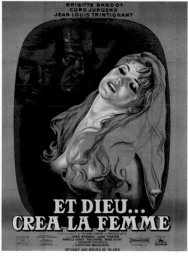

Clockwise from top: Scene from *And God Created Woman*, 1956: French theatrical poster of *And God Created Woman*; Brigitte Bardot in St. Tropez, Willy Rizzo, 1958

and dogs rescued in the animal rights campaign that preoccupied her for the rest of her life.

The rebuilt La Madrague, where she moved permanently in 1963, featured a high wall on the Mediterranean side to discourage paparazzi hoping to catch her in an unguarded moment. Some photojournalists resented her sudden insistence on privacy after years of courting the press. They picketed her home with placards complaining "In 1955, you sought us out; in 1965 you reject us."

St. Tropez and its deep sheltered anchorage continued to attract yacht owners and, increasingly, cruise ships to which passengers could return each night after a day of shopping in the town's pricey boutiques. Hotels opened, including, in 1967, the Byblos, supposedly named by Bardot for the resemblance of St. Tropez to the medieval city of that name on the Lebanese coast.

An elite location on the already highly fashionable Riviera, St. Tropez lured the cream of international celebrities. Jackie Kennedy Onassis stayed at the Byblos. So did a number of rock stars, including Mick Jagger. In 1971, he proposed to Bianca Pérez-Mora Macias in the hotel, and later married her in the town hall. The event became chaotic as paparazzi invaded the town hall. The bride, furious at having been required to sign a stringent prenuptial agreement, said "My marriage ended the day it began." In August 1997, Princess Diana and her lover Dodi Fayed spent their last days on his father's yacht moored off nearby Pampelonne Beach.

With as many as 100,000 visitors a day during the summer, but no public transport and little parking space, St. Tropez is a challenge to the casual tourist, although the rich continue to buy villas, which now cover the hillside above the town. Ironically, some of its best real estate has no houses—in particular the Cimetière Marin, or Sailors' cemetery, which offers spectacular sea views to its thousands of defunct inhabitants.

Epilogue

The Musée de l'Annonciade in St. Tropez contains a significant collection of art associated with the area, including Signac's *St-Tropez, Le Quai* (1899) and *Vue de St-Tropez, Coucher de Soleil au Bois de Pins* (1896), and Derain's vivid *Effets de soleil sur l'eau, Londres* (1905). The *Nabi* group are particularly well-represented, as well as notable artists who painted around St. Tropez, among them Vuillard, Bonnard, Derain, Matisse, Braque and Picasso.

Among those buried in the Cimetière Marin are two composers, Louis Durey of the 1920s experimenters known as Les Six, and Pierre Bachelet, whose film scores include those for the erotic *Emmanuelle* series. Also interred here are André Dunoyer de Segonzac and Roger Vadim, now appropriately a permanent resident of the town whose fame he helped create.

GRAHAM GREENE: The Dangerous Edge

In Graham Greene's 1955 short novel *Loser Takes All*, a millionaire businessman, based on movie producer Alexander Korda, quixotically invites one of his accountants to be married in Monaco on his yacht. When the mogul fails to turn up, stranding the couple without money, the accountant gambles at the casino. Though his roulette system wins a fortune, he becomes so preoccupied that his wife feels neglected and starts flirting with another man. Only by sacrificing his winnings can he regain her love. Loser takes all.

The story says much about Monte Carlo and its obsessive culture of chance but more about Greene, who, though regarded among the greatest living British authors at the time, chose to spend the last part of his life like a loser, living in modest obscurity on the Riviera.

Graham Greene with his lover, Catherine Walston

Metro Goldwyn-Mayer présente une production Peter Glenville
Richard Burton · Elizabeth Taylor
Alec Guinness · Peter Ustinov

Les Comédiens

D'après le roman de Graham Greene
avec Paul Ford · Lilian Gish Panavision · Metrocolor
Scénario de Graham Greene · Production et Réalisation de Peter Glenville

French poster of *The Comedians* directed by Peter Glenville, 1967

When a swindling accountant embezzled his
savings in 1965, Greene was ordered by the British
Internal Revenue to abandon his tax exile in
Switzerland by the end of the year. He took a room
at the Hôtel Royal in Antibes. Soon after, a windfall
from the film rights to his novel *The Comedians*
(1966) allowed him to buy a one-bedroom apartment
in the Résidence des Fleurs, a characterless modern

block near the seafront. It remained his home for the next twenty-six years.

A lifetime sufferer of bipolar depression, Greene looked on mankind, according to his cousin Barbara, companion on one of his African excursions, with the cold eye of a biologist studying the behavior of ants. His life in Antibes was little different to that of a fugitive, or a spy, the profession he followed for some years as an agent of British intelligence. His friends in the espionage community included notorious traitor Kim Philby. Greene visited him in Moscow. They carried on a long correspondence, and Greene wrote an introduction to his memoirs. Even in retirement, Greene kept his hand in. When he traveled, particularly to communist countries, MI6 (Military Intelligence, Section 6) paid his expenses in return for any useful gossip.

Younger writers such as John le Carré and Charles McCarry, both former intelligence agents, wrote of spying as high drama, a profession where lonely intellectuals matched wits, with the world at stake. Unlike them, Greene found espionage a little ridiculous. In *Our Man in Havana*, a British businessman in Cuba invents a network of spies by convincing Whitehall that the schematics of a vacuum cleaner are actually the plans of a secret weapon.

In 1973, Greene enjoyed fooling film director François Truffaut, who was shooting *La Nuit Americain—Day for Night*, at Nice's Victorine Studios. Hearing that Truffaut needed an English

actor to play an insurance adjuster, Greene's friend
Michael Meyer persuaded him to volunteer. Greene
played his small scene without a hitch. Only when
it was over did Truffaut frown and say "Your face
is familiar. Have you appeared in other films?"
Fortunately the director, who could be thorny, was
amused rather than offended by the trick.

Greene socialized little on the Riviera, least of all
with other expatriate writers. He had an amiable
but remote relationship with Lawrence Durrell,
who lived farther inland at Sommieres and shared
his enthusiasm for British sausages. However
he clashed with Anthony Burgess, a resident of
Monaco, who spoke disparagingly of Greene on the
French TV program *Apostrophes*, claiming, among
other things, that the Swiss husband of Greene's
mistress once stood outside his window, bawling
insults—impossible, Greene pointed out, as he lived
on the fourth floor.

Although they never met, Greene had more in
common with another Riviera resident, William
Somerset Maugham, whose flamboyant Villa
Mauresque on the point of Cap Ferrat was distantly
visible from his apartment. Former secret agents,
both travelled widely, often writing about the places
they visited in an unflattering way that irritated
the locals. Despite this affinity, Maugham would
probably have shunned those corners of the world
where Greene set his novels: the ruins of postwar
Vienna in *The Third Man* (1949), Cuba under Batista
for *Our Man in Havana* (1958), the Haiti of "Papa
Doc" Duvalier and his secret police, the Tontons

Macoutes, in *The Comedians*, or the Congolese leper colony of *A Burnt-Out Case* (1960).

Like other British writers before him, Greene found the Côte d'Azur, particularly out of season, an ideal place in which to work. In the fall, he wrote approvingly, "Antibes comes into its own as a small country town, with the Auberge de Provence full of local people and old men sit indoors drinking beer or *pastis* at the *glacier* in the Place de Gaulle. For a man who has reached the age when all he wants is some good wine and some good cheese and a little work, it is the best season of all."

Part of the pleasure of loitering in the café was eavesdropping. "I like overhearing more than I like being told," Greene said. In the story *Chagrin in Three Parts* (1966), he listens as an older and more knowing woman at the next table lures her vulnerable younger companion into a lesbian relationship, while in *May We Borrow Your Husband?* (1967), two homosexuals seduce the male half of a honeymooning couple under the nose of his naïve wife.

Appropriate to someone preoccupied with sex and enamored of deception, Greene enjoyed numerous relationships with married women. In the 1950s, they included Swedish actress Anita Björk, widow of the writer Stig Dagerman. Resentment of this liaison by a member of the Nobel Prize committee is widely believed to account for Greene's continued failure to win this most coveted of honors.

A major attraction of Antibes was the presence in nearby Juan-les-Pins of a former mistress, Yvonne Cloetta. Eighteen years his junior, she met Greene in Africa while he was researching *A Burnt-Out Case* (1960). Though Cloetta remained married and they never lived together, she became his companion for the last part of his life. Small and vivacious, with a liking for colorful clothes and lots of jewelry, Cloetta wasn't particularly literary, and they seldom discussed writing. "After his two or three hours' work in the morning," she said, "he was very disturbed and unsettled. He needed someone to help him come out of that other world, to talk about this and that, to return to a normal life; he needed someone to hold out a hand and lead him back. I felt that and I very quickly accepted it."

Initially, they met at the Hôtel Royal. The owner recalled "She would arrive some afternoons and just slip up into his room. No one would comment. It was all conducted with much delicacy." Once he purchased his apartment, they settled into a routine. Although, on special occasions, they dined at La Reserve, a few miles along the coast at Beaulieu-sur-Mer, he, Cloetta and her spaniel Sandy preferred Chez Felix, a restaurant in the old town. Traditionally, lunch began with a dry martini, followed by *boudin* sausage and a bottle of red wine from Château des Garcinières near St. Tropez. It appealed to Greene's frugal nature that Felix charged them only for what they drank, and kept the remaining wine for his next visit.

After lunch, he and Cloetta returned to his

Authors Graham Greene and Michael Mewshaw outside Chez Felix Restaurant, Antibes, 1976

apartment, where, before returning home at the end of the day, she prepared his dinner. Without her help, both emotional and practical, Greene could barely have survived in Antibes. As the writer Paul Theroux explained, "Greene could not cook, he was incapable of using a typewriter, he did not wield a mop; he was a naturally dependent, not to say helpless man. Add to this the astonishing fact that, though a traveler, a seeker of danger, a deeply curious wanderer who was seldom home, he could not drive a car."

Always drawn to what poet Robert Browning called "the dangerous edge of things," Greene became involved in a political scandal on Cloetta's behalf. Corruption was rife in Nice. The mayor, Jacques Médecin, surrounded himself with former members of the OAS, the terrorist group that fought Algerian independence and once tried to kill General de

Gaulle. Médecin's official photographer, Alberto Spaggiari, committed a notorious 1976 bank robbery in Nice, but escaped, probably with the mayor's help.

Cloetta's daughter, divorced from a local Nicois of dubious reputation, had been awarded custody of their two children. The ex-husband kidnapped their eldest daughter, but the courts, flouting all legal precedent, allowed him to keep the child. In 1982, Greene published a thirty-three-page booklet called, in a nod to Emile Zola's spectacular intervention in the Dreyfus case, *J'Accuse*, but subtitled *The Dark Side of Nice*. It began "Let me issue a warning to anyone who is tempted to settle for a simple life on what is called the Côte d'Azur. Avoid the region of Nice which is the preserve of some of the most criminal organizations in the south of France."

As a symbol of his disgust, Greene sent back the medal of the Legion d'Honneur awarded by the French state. It was returned, with the explanation that the honor could be rescinded only by death or disgrace. Médecin successfully sued Greene for libel, although he had his revenge when the mayor was later convicted and jailed.

Greene remained in Antibes until 1990, when he returned to Switzerland for hospital treatment. He died in Vevey on April 3, 1991. He and Yvonne Cloetta shared a small apartment there during his last months—a fact resented by Greene's wife Vivien, even though she and Greene hadn't lived together since 1948. "She had made him very happy these last times," Vivien conceded. "Of course, he wasn't

faithful to her, just as he wasn't to anybody else, but she was nice and kind. She came to the funeral. And she came—which seemed to me in rather poor taste—to the memorial service in Westminster Cathedral."

Greene was buried in the village of Corseaux, outside Vevey. His gravestone was designed by the same artist who drew the covers for the Penguin paperbacks that provided his widest readership. The priest who officiated said optimistically "My faith tells me that he is now with God, or on the way there." Greene, forever the sceptic, might not have concurred.

Epilogue

In Antibes, Greene is commemorated by a plaque outside the entrance of the Résidence des Fleurs on Rue Pasteur.

MONTE CARLO: A Sunny Place for Shady People

Asked to describe Monte Carlo, most people who have visited the Riviera's casino capital respond, "Well, have you been to Las Vegas?" It's an apt comparison. Both cities are synthetic, created by the same business: gambling. Each flourished on casino profits, which attracted disreputable elements. As writer William Somerset Maugham remarked, "Monte Carlo is a sunny place for shady people."

Before 1866, Monte Carlo didn't exist. There was only Monaco, Europe's tiniest country. Smaller than New York's Central Park, wedged between Italy and France, it was a relic of the years before Italy's regions united. Ruled for centuries by the Grimaldi family, Monaco clung to its independence, always aware that, under a treaty with France, it would

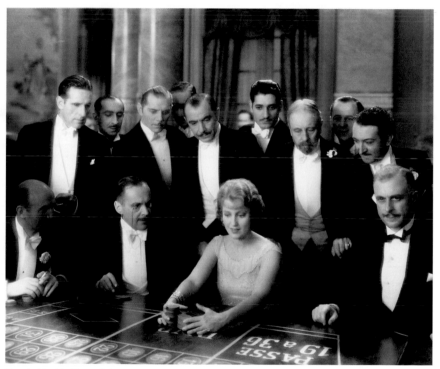

Ernst Lubitsch's *Monte Carlo*, 1930

Vintage postcard of Monte Carlo

be swallowed by its neighbor if no male Grimaldi occupied the throne.

Close to bankruptcy in the mid-1800s, it had the sense to legalize gambling, though not the skill to make it profitable. The first casino opened in 1856. After other entrepreneurs failed, the concession was sold in 1863 to François Blanc, who had transformed the spa town of Bad Homburg in Germany by building a casino there.

Seeing that his predecessors had not learned the first rules of real estate—location, location, location—Blanc selected a promontory overlooking the Mediterranean, known as Les Spélugues (The Caves) because of grottos in the cliffs once used for burials. Demolishing the slums that covered it, he built a palatial casino, Les Spélugues, completed in 1863, with Gobineau de la Bretonnerie as architect. As a compliment to the reigning prince, Charles III, the district was renamed Mount Charles in 1866—in Italian "Monte Carlo."

As soon as new roads and the railway made it accessible to the cities of both Italy and France, Monte Carlo flourished. Luxury hotels catered to wealthy visitors and those who served or exploited them. Gambling made the principality so prosperous it could abolish income tax for its citizens, turning it into a haven for the rich of every nation.

Monaco became the jewel of the Riviera. Describing the experience of sailing into its harbor, American novelist Edith Wharton could barely contain her admiration. "Unclouded sunlight enveloped sea and shore in a bath of purest radiancy. The purpling waters drew a sharp white line of foam at the base of the shore; against its irregular eminences, hotels and villas flashed from the greyish verdure of olive and eucalyptus; and the background of bare and finely-penciled mountains quivered in a pale intensity of light."

Although Monte Carlo remained synonymous with gambling, François Blanc surrounded his operations with so much ritual that a casino visit could be as eventful as a night at the opera. No Monegasque (local person) was permitted at the tables— passports had to be shown at the door. Evening dress was obligatory, even for croupiers—whose jackets, to forestall temptation, had no pockets. Even celebrities were turned away if inappropriately dressed. Told he must wear a tie, Harpo Marx used one of his socks to improvise one. The poet Dorothy Parker, warned she had to wear stockings, wrote "I went and found my stockings, then came back and lost my shirt."

Most players were satisfied with a drink at the bar and the chance to lose a few hundred francs at various minor games in the first *salle*, known dismissively as "the kitchen." Serious gamblers headed for the *salle privé*, where there was only roulette, and stakes were higher. When a player won more cash than the croupier had on hand, the table was draped in black until funds were transferred from the vaults. In such cases, the winner was said to have "broken the bank." In 1891, British con-man Charles Wells achieved this feat when he multiplied the proceeds of a swindle into millions of francs with a freak run of luck. The following year, the music hall song *The Man Who Broke the Bank At Monte Carlo* became an international success.

Wells was an exception in leaving with more money than he brought. The odds against this were massive. Even so, people sat at the tables for months, pursuing systems that they believed would make them rich, but which generally left them destitute. Under the headline "Lured to Ruin at Monte Carlo," the *New York Times* in 1912 described American women selling their jewels to buy more chips, and expatriates passing the hat to pay the hotel bill of a bankrupted friend.

Books and films about Monaco stressed the moral decay induced by a culture preoccupied with chance. The first and most lavish such production was Erich von Stroheim's 1922 *Foolish Wives*, of which he was the director, cowriter and star, playing a Russian count who, with two female "cousins," operates a counterfeiting scam while also shaking

down a naïve American diplomat and seducing his wife.

A stickler for authenticity, von Stroheim insisted on building a full-size facsimile of the Monte Carlo casino and the square in front. This pushed the budget over $1 million—the first film to break this barrier. For the title card that introduced the enormous reconstruction, von Stroheim let language run amok.

> Monte Carlo! Brine of the Mediterranean. Breeze from Alpine Snows—Roulette—Trente-et-Quarante—Ecarte—Mondaine—Cocotta—Kings and Crooks—Amoura! Amoura! And Suicides—and waves–and waves–and waves!

Just as his version of Monte Carlo exceeded any casino known in America, his character, Count Karamzin, is the European decadent to end them all: in a publicist's description "The Man You Love To Hate." After beginning the day with a little

Erich von Stroheim and Mae Busch (right) in *Foolish Wives*, 1922

pistol practice, he sits down to a glass of fresh bull's blood, followed by his "cereal"—heaping spoonsful of caviar. American audiences were mesmerized by this wildly imaginary lifestyle, which other émigré filmmakers copied. Even though his theme of a girl helpless in the hands of a mad hypnotist had more in common with the horror film, Rex Ingram, filming William Somerset Maugham's *The Magician* in 1926 at Nice's Victorine Studios couldn't resist including a Monte Carlo casino sequence.

Other filmmakers concentrated on the servants and hangers-on. In Ernst Lubitsch's 1930 *Monte Carlo*, hunchbacks who, by French tradition, have an uncanny skill with money, loiter outside the casino, ready, for a small fee, to have their backs rubbed for luck. Fiction writers too contributed to the mythology. The stunt performer of Maugham's 1935 short story *Gigolo and Gigolette*, risking her life nightly by diving into a pool of flames as part of a cabaret show, suffers from the same single-minded obsession with chance. "The dinners and suppers and the two cabaret shows that accompanied them," writes Maugham, "were only provided to induce people to lose their money at the tables."

"Everywhere, you were reminded of the casino," wrote Graham Greene in the 1940s. "The bookshops sold systems in envelopes, '2500 francs a week guaranteed'; the toyshops sold small roulette boards; the tobacconists sold ashtrays in the form of a wheel, and even in the women's shops there were scarves patterned with figures and *manqué* and *pair* and *impair* and *rouge* and *noir*."

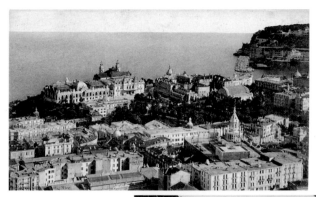

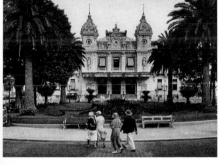

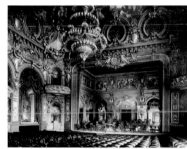

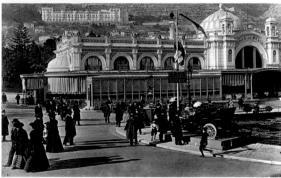

From top to bottom: Vintage postcard of Monte Carlo; Monte Carlo Casino, 1937; Concert hall of the Monte Carlo Casino (Salle Garnier), c. 1879; Café de Paris, 1870

Every event to take place in Monte Carlo was scrutinized for omens of good fortune. On a statue of Louis XIV in the lobby of the Hôtel de Paris, opposite the Casino, the right knee of his horse gleamed from where people rubbed it for luck. For a time, gamblers jammed services at the Anglican church when a rumor spread that someone had won by betting the number of the first psalm read.

Seeking ways to prolong the season, the government added a 524-seat theatre to the main casino in 1879. Its architect, Charles Garnier, also designed the Paris Opera (Salle Garnier). Too small for serious productions, it nevertheless staged the premieres of Berlioz's *La Damnation de Faust* in 1893 and *Don Quichotte* by Massenet in 1910. Such stars as Feodor Chaliapin, Enrico Caruso, Nellie Melba, Adelina Patti and Lily Pons all sang here. After World War I, Sergei Diaghilev moved his Ballets Russes to Monaco, making it his permanent headquarters.

After the arts, Monaco tried other diversions. In 1905, a journalist wrote that "for two or three years, the famous and fashionable have been saying, 'We are here in the country of sunshine; of caressing breezes and fresh air. Yet you keep us locked up in those gilded cages you call theatres. Quick, quick; organize some sport.'" Before long, the city was hosting an automobile show, as well as rowing, fencing and shooting competitions. Von Stroheim's silent film *Foolish Wives* demonstrated one popular pastime—pigeon shooting, but with live birds, which were startled into the air at a signal and blasted with a shotgun as they flew off.

Encouraged by the reigning prince, Albert I, an enthusiastic sailor who built the city's still-impressive Oceanographic Museum, Monte Carlo also staged regattas for yachts and speedboats. These attracted the automobile industry, which used the craft to test its new engines. Once Formula One road racing became established, it also launched a Grand Prix in 1929. With no room for a separate track, cars raced through the narrow city streets and along the seafront, frequently crashing into lampposts, trees, or shop windows.

Monaco produced no artists to rival its sportsmen, though some foreign writers moved there to avoid tax. They included British-born Anthony Burgess, prolific author of such novels as *A Clockwork Orange*, and the Hungarian Baroness Orczy, famous for her stories of the French Revolution and Sir Percy Blakeney, an apparent wastrel and fool who, as the Scarlet Pimpernel, daringly smuggles aristocrats to safety. The Baroness remained in her Villa Bijou throughout World War II, terrified to speak English for fear she would be arrested by the Gestapo whose headquarters were nearby.

During the 1950s, a succession of constitutional crises threatened the principality. President Charles de Gaulle, angered by the number of Frenchmen moving there as tax exiles, threatened to disconnect its water supply. French soldiers patrolled the frontier, poised to turn back food supplies and starve the Monegasques into submission.

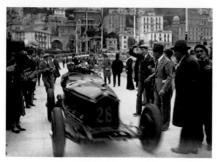

Tazio Nuvolari at the 1932 Monaco Grand Prix with Alfa Romeo Monza 2.3

At the same time, Prince Rainier III had no heir. Fortuitously he met Grace Kelly when she visited the Cannes Film Festival. Returning in 1955 to star with Cary Grant in Alfred Hitchcock's *To Catch a Thief*, she accepted his offer of marriage, for which Rainier ditched his mistress, actress Giséle Pascal, and Kelly her lover, actor Jean-Pierre Aumont. They were married in 1956, and Kelly ensured the succession by producing a son, Alfred, as well as two daughters, Stéphanie and Caroline.

Glamorous and wild, the Rainier daughters were so often in the news that photo magazine *Paris Match* paid for the exclusive right to report their activities. Seventeen-year-old Stéphanie survived the fatal 1982 accident when her mother's car ran off a cliff. Officially Grace suffered a stroke while driving, although rumors suggested her daughter was at the wheel, while others hinted that the crash might have been engineered by "shady people" as a warning to the royal family of who actually ran the principality.

In its randomness and ambiguity, Grace Kelly's death was worthy of the movies in which she starred, but one expected no less of a city founded

on cynicism and sustained by chance. "I had a continual restless feeling," wrote the novelist Willa Cather, "that there was nothing at all real about Monte Carlo; that the sea was too blue to be wet, the casino too white to be anything but pasteboard, and that from their very greenness the palms must be cotton."

Epilogue

Monte Carlo today boasts four casinos. The original, which continues to offer roulette and other classic table games, has been joined by the Casino Café de Paris, the Sun, which aims for a Las Vegas-style experience, and the Bay and Summer casinos, combining gambling with resort facilities. In most of these, slot machines dominate. The dress code has been relaxed, particularly in low season, but a jacket is usually required in the evening, and sneakers are frowned upon.

The Oceanographic Museum, opened in 1910, is among the world's most opulent. Built on a palatial scale, it clings to a cliff at the very edge of the sea it celebrates. As well as nautical memorabilia and an aquarium, exhibits include sculptures and installations inspired by the ocean.

The 1966 film *Grand Prix* commences with a collision during the Monte Carlo race in which James Garner's character ends up in the harbor. The following year, racecar driver Lorenzo Bandini died during the Grand Prix in a similar accident on the same spot. After protests from drivers, safety for the Monaco event was considerably improved.

TO CATCH A THIEF: Crime in the Sun

Given the tendency of the rich to follow the sun, it's no wonder that crime rates along the Mediterranean are among the highest in France.

Professional criminals targeted the Riviera almost as soon as the aristocracy of Europe chose to spend winters there. Monte Carlo's casino became a popular target. As early as 1903, a gang of four scored a coup at the roulette table. Just as the wheel stopped spinning, a woman turned to her neighbor—an accomplice—and accused him of snatching some gold coins from the table. This distracted the croupiers while another of the gang placed a bundle of cash on the winning number. The croupiers protested, but a fourth member insisted it had been there before the spin, so the casino paid up.

Theatrical poster for the Alfred Hitchcock film *To Catch a Thief*, 1955

The Casino at Monte Carlo, 1890, Jean-Georges Béraud

Not long after, it ceased using cash and switched to chips and plaques, but con men soon had that licked too. In one popular scam, a personable young man accosted a couple arriving at the casino and explained he was a servant at one of the hotels. A departing guest had given him a munificent tip in the form of a casino plaque but as a Monegasque, he was forbidden to enter. He asked the tourists to cash it while he waited outside, a service for which he promised them a hefty reward. As insurance that they'd return, he had them leave money, a watch or a ring with him. The plaque was, of course, fake, and the victims never saw him again.

Casinos suppressed details of thefts and losses for fear bad publicity would deter gamblers. When, as occasionally happened, a loser killed himself on the premises, the management stuffed his pockets with money to suggest the death had nothing to do with gambling. This practice ceased after con men staged a fake suicide and made off with the cash.

The casino's next solution was less subtle. In 1912, the *New York Times* quoted a visitor who "noticed an elderly man sitting alone on a bench. While my back was toward him, I heard a pistol shot. Two policemen rushed up and hauled the body rapidly down the staircase [and] into one of the railroad station's waiting rooms outside." Unlike Las Vegas, what happened in Monte Carlo didn't necessarily stay there.

As casinos improved security, thieves turned their attention to such hotels as Cannes' Carlton—one of the settings for the most famous film about robberies on the Riviera, Alfred Hitchcock's 1955 *To Catch a Thief*. Few real-life jewel thieves were as suave as Cary Grant's John Robie, a circus performer turned cat burglar who creeps across the roofs at night, slips into a hotel room, and steals the jewels without the owner being any the wiser.

In the film, Robie has won his freedom by courageous service in the wartime resistance—a detail taken from real life. Many members of the secret army were jailed criminals who escaped in the chaos of the German invasion, fought for the resistance or *maquis* (meaning undergrowth or bush land), but returned to their former trade after the war. (In a nod to this fact, the speedboat driven by Brigitte Auber in the film is called *Maquis Mouse*.)

Among the most prominent recidivists was Jean Jehan, a Corsican, who masterminded the operation to smuggle heroin into the United States that became famous as the *French Connection*. As the

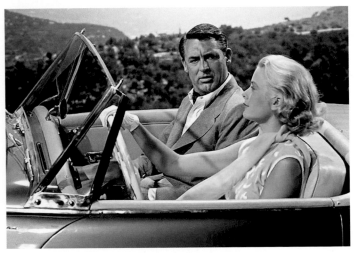

Cary Grant and Grace Kelly in *To Catch a Thief* (1955)

Riviera's major port, Marseille had a long association
with crime, in particular smuggling, which, like many
illicit enterprises along the Riviera, was dominated
by Corsicans. They controlled prostitution and
human trafficking, trading women between brothels
in Paris and South America. The biggest profits,
however, were in drugs, known in slang as *chnouf,*
most of which entered France through its docks.

Before World War II, the bulk of raw opium came
from Indochina, but as France lost its colonies,
dealers turned to Turkey. Gum from Turkish poppies
was refined into morphine in Beirut, further purified
in Marseille, then shipped to the United States.
Tourists, businessmen and returning servicemen,
even diplomats became "mules" for the drug. In
1960, the Guatemalan ambassador to Belgium,

the Netherlands and Luxembourg was caught
transporting morphine under diplomatic immunity.

Jean Jehan, acknowledged brains behind the
operation, ran rings around law enforcement in
both the United States and France. When William
Friedkin made his film *The French Connection*
in 1971, Jehan, referred to by the film's stars,
Gene Hackman and Roy Scheider, as "Frog One,"
was played with amused assurance by Spanish
leading man Fernando Rey. He's last seen sailing
out of Marseille harbor on his yacht, a beautiful
companion at his side, headed, as in real life, to
retirement in comfortable obscurity.

Albert Spaggiari, the man behind the most famous
Riviera robbery of the 1970s, emerged from
the OAS, a terrorist group set up to oppose the
independence of French Algeria. Spaggiari was
close to Nice's shady mayor Jacques Médecin, who
surrounded himself with former OAS gunmen. In
1976, under cover of the July fourteenth national
holiday, Spaggiari and his gang burrowed through
the sewers of Nice into the vaults of the Société
Générale bank, broke open 400 safety deposit boxes,
and stole sixty million francs in jewels, securities
and cash. The robbery was carried off in true
Riviera style. The thieves enjoyed a picnic lunch
in the vault, on the wall of which, before leaving,
Spaggiari painted the words *"sans armes, ni haine,
ni violence"*—without guns nor hate nor violence; in
other words, a gentlemanly theft.

Betrayed by a girlfriend, Spaggiari was arrested as

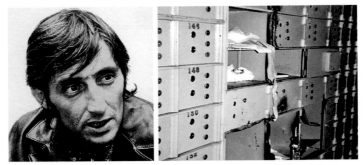

Albert Spaggiari and broken safe deposit boxes in the Société Générale Bank, 1976

he left the plane on which he'd been touring the Far East as mayor Médecin's cameraman. Placed on trial, he convinced the judge that a document was written in a code only he could decipher. Invited into the judge's chambers to decode it, he leaped from the window and sped away on a motorcycle. Neither he nor the money were ever seen again.

Recent Riviera robberies have been more profitable than Spaggiari's, but lacked his flair. As luxury shops proliferated along the Boulevard de Croisette in Cannes and around the Carlton Hotel where Cary Grant and Grace Kelly begin their romance in *To Catch a Thief*, "smash and grab" thefts became more common.

On July 28, 2013, the Carlton was about to present a six-week "Extraordinary Diamonds" exhibition, organized by Israeli billionaire Lev Leviev with items provided by the luxury jeweler Chopard. A single thief, masked and armed, entered through an unlocked window, forced the three exhibition staff

and the three security men (all unarmed) to lie on the floor, and left with $136 million worth of earrings and watches.

A few days later on July 31, two thieves robbed the Kronometry watch shop opposite the red-carpeted steps of the Palais des Festivals, on which movie stars pose for photographs. Menacing the staff with a pistol and a grenade, they walked off with forty watches valued at hundreds of thousands of dollars. Local police were doubly embarrassed since it was the second time the store was robbed that year.

Many recent thefts are the work of the so-called "Pink Panthers" gang, named for the series of film comedies and cartoons about bumbling Inspector Clouseau struggling to capture a sophisticated and slippery jewel thief. In 2014, a squad of armed police arrested three members of the gang as they loitered near the Monte Carlo casino. "They were hard-looking men," said a witness, "but dressed in designer casual wear and sunglasses. The square is full of jewelry shops, and it seemed they were planning an armed raid."

An English loss adjuster from the company that insured the jewels stolen from the Carlton responded to the robberies with the same rueful resignation as his opposite number in *To Catch a Thief*, played by veteran British character actor John Williams. Complimenting the gang on its audacious speedboat escape from a robbery in St. Tropez, and also on the way, to discourage witnesses to a Cannes robbery, it painted a bench outside the target store,

complete with "Wet Paint" sign, he said "I hate using the term 'professional', but you have to give them some grudging respect."

Trying to see the bright side, Cannes' deputy mayor said "We shouldn't be surprised by armed thefts. They have always existed. In a way, it adds to the fame of the Croisette." The boss of Kronometry agreed. "The day when there are no longer any luxury brand shops on the Croisette, Cannes will no longer be Cannes." For those who sell to the rich, losing a few million may just be part of the cost of doing business.

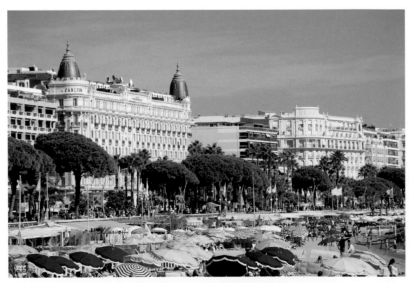

Carlton Hotel, Croisette Boulevard, and beach

Epilogue

The Riviera has no shortage of books and films about crime, beginning with David Dodge's original novel *To Catch a Thief,* which Hitchcock so effectively adapted. Agatha Christie set her *The Mystery of the Blue Train* (1928) en route to the Riviera and in 1931 Georges Simenon wrote two of his novels about Inspector Maigret while holidaying in Antibes.

Films about Riviera casino robberies include *Seven Thieves* (1960), from a novel by French author Max Catto in which a gang robs the Monte Carlo casino by faking a medical emergency and escaping by ambulance. More inventively, in 2002 Irish director Neil Jordan remade Jean-Pierre Melville's classic "caper" movie *Bob Le Flambeur* as *The Good Thief,* transferring the setting from Deauville to Monte Carlo and giving a modern gloss to the ironically self-destructive central character, played here by Nick Nolte.

Real-life killings on the Riviera mostly involve that incendiary combination: sex and money. The violent death in 2004 of Anthony Ashley-Cooper, 10th Earl of Shaftesbury, is among the most lurid. At sixty-six, Lord Ashley led a playboy existence. Notable for his black leather trousers, pink shirts and gaudy eyeglasses, he enjoyed the company of exotic women, of which the Riviera had no shortage. In 2002, he married Jamila Ben M'Barek, a Tunisian "escort" who had modeled nude for *Playboy*. The owner of the agency who employed her testified that M'Barek asked to be introduced to wealthy men as potential husbands. Shaftesbury was ideal. He bought her an expensive Cannes apartment and gave her other properties. When, after two years, he wearied of the relationship and took up with Nadia Orche, a no-less-exotic Moroccan, the Earl disappeared. In 2005, Jamila confessed to paying her brother to murder him.

FOLLOWING THE SUN: The Victorine Studios

When Auguste and Louis Lumière made their first pioneering films in 1895, they shot some of them in and around La Ciotat, the village outside Marseille where the family spent its summer holidays. One of them, showing a train entering the La Ciotat station, appeared so real that audiences bolted for the exits, convinced the locomotive would plunge out of the screen and into their laps.

With real estate so cheap and sunshine so plentiful, France's filmmakers might have been expected to settle along the Mediterranean, as their American opposite numbers colonized California. But the French preferred Paris, where performers and technicians were plentiful and social life less provincial. A few studios limped along on the

Metro presents

REX INGRAM'S
SCARAMOUCHE

*From the famous novel of
the French Revolution by*
RAFAEL SABATINI

Adapted by WILLIS GOLBECK
Photographed by JOHN F. SEITZ

featuring
ALICE TERRY
LEWIS STONE
RAMON NOVARRO

A **Metro** Picture

PRICE 25¢

Rex Ingram on the movie poster of *Scaramouche*, 1923

Riviera in the early days of cinema, but only one survived—the Victorine Studios at Nice.

That said, Victorine was in trouble from the moment producers Serge Sandberg and Louis Nalpas started building in 1921. World War I had left European cinema in ruins, and American companies were buying up the remnants at bargain rates. As well as moribund theatre chains, they hired the best French and German set designers, costumiers and cinematographers. Shipped back to California, these artisans were put to work making films to feed the now-multinational U.S. industry. French, German and British filmmakers frequently found their productions blocked from their own cinemas, which now belonged to Hollywood and showed only its films.

Before the war, such producer/directors as D. W. Griffith and Thomas Ince in the United States and Marcel L'Herbier and Abel Gance in France could work as independents, keeping the same technicians and performers. Hollywood's factory system swept that away. Among the few exceptions were those directors who controlled a major female star: Mauritz Stiller with Greta Garbo, Eugene Frenke with Anna Sten, Josef von Sternberg with Marlene Dietrich. Reluctant to break up a winning team, studios permitted these couples to continue working together, at least as long as their films made money.

Victorine was saved by just such a team, the actress Alice Terry and Rex Ingram, her Irish-born

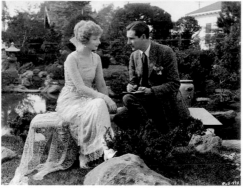

From top: Alice Terry and Rudolph Valentino in *The Four Horsemen of the Apocalypse*, 1921; Alice Terry with husband Rex Ingram, November 1921

American director husband. Ingram, flamboyant and handsome, a former actor, enlisted in World War I as a flight instructor and incurred injuries that troubled him all his life. Befriending June Mathis, head of the Metro-Goldwyn-Mayer story department, he received some plum jobs, including *The Four Horsemen of the Apocalypse* (1921), an epic of World

War I that starred then-unknown Rudolph Valentino, dancing his famous tango, and a beautiful ingénue, Alice Terry.

The film made all three into stars. Ingram married Terry, and transformed her. Once he made her lose weight, fixed her teeth, and most important, put her in a blonde wig, she became, in the words of critic David Thomson, "one of the great beauties of silent films."

Ingram was a stickler for authenticity, like his friend Erich von Stroheim, who called him "the world's greatest director." Both would shoot a scene repeatedly until every detail satisfied them. Even extras had to wear specially sewn costumes, made from the most expensive materials. Acres of ground were ploughed up to create realistic battlefields. For scenes set in France, Ingram required all actors to speak French, even though the film was silent.

Ingram relished fantasy and extravagance. Honoré de Balzac's novel *Eugénie Grandet* is a staid fable about the perils of miserliness. When Ingram filmed it in 1921 as *The Conquering Power*, it became a melodrama of Rudolph Valentino's love for Alice Terry, which is frustrated by her miserly father. Among the scenes Balzac never imagined, a Paris birthday party culminates in a scantily dressed girl carried in on a huge dish. Later, Valentino's miser uncle goes mad and imagines himself attacked by a gilded demon representing his greed. Claws grope for him from a cradle filled with coins. As the walls of his treasury close in, he's

crushed under the weight of his own safe, gushing a fortune in gold.

After *The Four Horsemen of the Apocalypse*, Ingram and Terry, with Mathis's help, made *The Prisoner of Zenda* (1922) and *Scaramouche* (1923), both profitable adventure/romances for MGM. But audiences were tiring of costume films. One exhibitor wrote to the studio "Don't send me no more of them, movies where the hero writes his name with a feather."

In 1924, Ingram went on location in North Africa for *The Arab*, with Terry as a Christian missionary and Ramon Novarro as a Bedouin sheik. On his return, he persuaded MGM that he could make more of these exotic romances for less money if he relocated in Europe. At his urging, MGM paid to update the Victorine Studios, and Ingram and Terry, with their team of technicians, including his preferred cinematographer and editor, moved to Nice permanently.

Ingram hoped other American directors would join him, enjoying what he claimed were lower production costs and freedom from studio interference. Initially, the omens were promising. He found plenty of low-priced help, including the teenage son of an English hotel owner. Michael Powell was hired to mop dusty footprints from the gleaming black floors of Ingram's lavish sets. Graduating to actor and assistant director, Powell would return to Victorine many years later as director of *The Red Shoes* (1948).

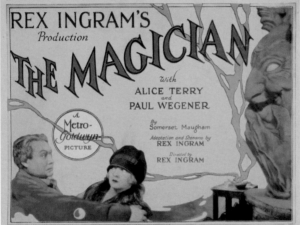

Ingram as Director

Clockwise from top left: Rex Ingram directs *The Four Horsemen of the Apocalypse*, 1921; Ingram, Herbert Howe, Alice Terry, and Ramon Novarro filming *The Arab*, 1924; Theater poster of *The Magician*, 1926; Alice and Antonio Moreno in *Mare Nostrum*, 1926

Exhilarated by his freedom from studio control, Ingram lavished time and money on his first film with Terry, the espionage story *Mare Nostrum* (1926). It took fifteen months to shoot, but Ingram managed to keep its costs from the accountants in New York. Their next film, *The Magician* (1926), was adapted from a novel by fellow Riviera resident William Somerset Maugham, who had been inspired by the mystic, devil-worshipper and self-styled "Great Beast" Aleister Crowley. In the novel, he became Oliver Haddo, a figure with apparently supernatural powers who believes he can create life with a potion that requires the heart's blood of a virgin. Hypnotizing a beautiful sculptress, he spirits her away to his mountaintop tower where, in the middle of a thunderstorm and aided by his dwarf assistant, he is about to plunge a knife into her heart when her lover arrives to rescue her.

As Haddo, Ingram hired lumbering, wild-eyed German actor Paul Wegener, already famous for playing another monster in *The Golem*. *The Magician* proved influential in Hollywood, where the climax, with lightning playing around the mountaintop tower and Wegener and his assistant menacing the helpless Terry, bound and gagged, inspired scores of horror films, in particular *Frankenstein* (1931).

Ingram returned to the desert for *The Garden of Allah*, the story of a French Trappist monk who abandons a North African monastery, marries, fathers a child but, unable to forget his vows of poverty, celibacy and silence, returns to the church,

leaving Alice Terry to languish with their child. Ingram's desert locations were almost sufficiently beautiful to disguise the ridiculous plot, but his people working on the film noted uneasily that Ingram's health was deteriorating, as was his relationship with Terry, who now lived in her own villa and increasingly influenced his productions.

As the shooting of *The Garden of Allah* ended, MGM's head Louis B. Mayer realized what *Mare Nostrum* had cost, and attempted to impose a happy ending on the latest production in order to make it more commercial. When Ingram refused, MGM pulled out of Victorine, forcing Ingram to buy the studios himself. He used them to shoot his last silent film, *The Three Passions* (1929), and his first in sound, *Baroud* (1932), but poor health, the loss of his U.S. base and the increasing pace of new technology overwhelmed him. Despite attractive photography in North Africa, *Baroud,* in which Ingram also, ill-advisedly, acted, was a flop in both its English and French versions. Abandoning film entirely, he returned to California, becoming a sculptor and writer. He also converted to Islam.

The French Gaumont company bought Victorine in 1932, paid to upgrade it, and made a number of films there during the 1930s, many starring popular horse-faced comedian Fernandel, who was born in Marseille. During World War II, with France under Nazi occupation, Parisian filmmakers migrated to the south, where the Italians, more amenable than the Germans, were in charge, and were even prepared to invest in co-productions. One of France's leading

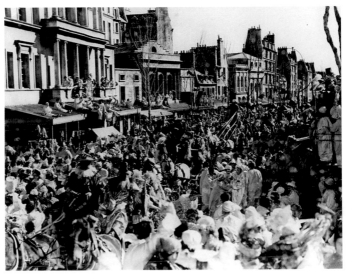

Scene of *Les Enfants du Paradis* at the set of The Victorine Studios

directors, Marcel Carné, relocated to Nice for his
fantasy *Les Visiteurs du Soir—The Night Visitors*,
in 1942 but his most important film of the time was
Les Enfants du Paradis (The Children of Paradise)
for which he recreated Paris's theater district of the
1840s.

Finally released in 1945, *Les Enfants du Paradis*
was a miracle of invention. During the production,
Jewish composers and designers were forced to
work under cover, starving extras ate all the food
laid out for the characters in the film, and the
actress Arletty, notoriously promiscuous, carried
on open affairs with various German lovers. As
the war began to go against the Axis, the Italian
co-financiers pulled out and members of the

resistance began to purge Nazi collaborators among the cast. Against all odds, however, the film was hugely successful. As for Arletty, she shrugged off her Teutonic liaisons. "My heart is French," she explained, "but my ass is international."

Victorine flourished intermittently for the next twenty years, although filmmakers frequently used it only for interiors, shooting mostly outside in the abundant Riviera sunshine. The most enduring film to be produced there was Alfred Hitchcock's *To Catch a Thief* in 1955. Roger Vadim also used it for the interiors of *Et Dieu ...Créa la Femme* with Brigitte Bardot.

Victorine's success inevitably attracted crime. During the 1970s, Nice's corrupt mayor Jacques Médecin placed his cronies in charge. Income that should have been used to maintain the facilities went into their pockets. In the mid-1980s, Michael Douglas and his brother Joel, sons of actor Kirk Douglas, took control, but did little to halt its decline. "We had a lot of hope when the Douglas brothers came," said one employee, "but Michael hardly ever showed up, and Joel just played pinball all day."

Victorine still operates, but the city of Nice now owns the land and plans to use it to build apartments. If it does, it will be without the agreement of Victorine's oldest inhabitant— the ghost of Rex Ingram, still said to roam the crumbling buildings and overgrown backlot.

Epilogue

In 1973, François Truffaut made a tribute to Victorine in *La nuit américaine—Day for Night*, a comedy about the difficulties of producing a movie there. Playing the director, Truffaut attempts to make a film called *Meet Pamela*, only to be impeded by love affairs among the cast and crew, numerous technical problems, and the death of a star. His character compares the experience of filmmaking at Victorine to taking a stagecoach ride through Indian territory in a western: you set out cheerfully, but by the end you are happy just to survive.

RED CARPETS AND GOLDEN PALMS: The Cannes Film Festival

Few events offer more publicity for less investment than a film festival. Unlike opera, drama or dance, movies require no loudspeakers, flood lighting or special seating. Screenings can take place in existing cinemas, or even outdoors, in some picturesque ruin. A single film print or disc, compact and easy to handle, provides hours of diversion, and is indefinitely repeatable. As for filmmakers, they not only offer their work free; many attend the festival at their own expense, in hopes of a moment in the limelight, or a prize.

Credit for inventing this provident event belongs to Italian dictator Benito Mussolini, who inaugurated

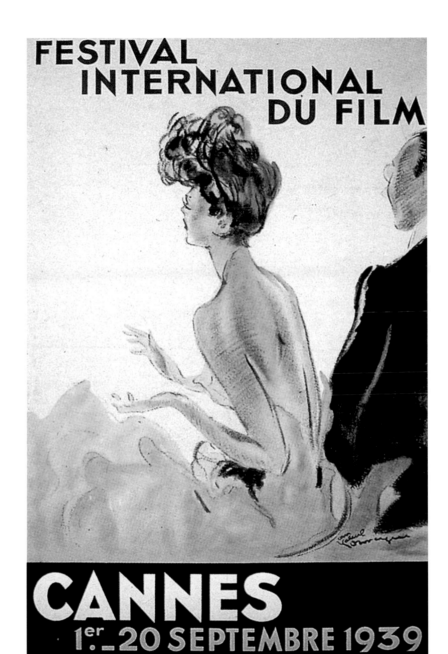

The official poster of Cannes Film Festival, Jean-Gabriel Domergue, 1939

Venice's *La Mostra Internazionale d'Arte Cinematografica* in August 1932. France's Inspector General for Education, Philippe Erlanger, attended in 1938, and returned home fuming after the prizes went to Luciano Serra's *Pilota*, celebrating Italy's invasion of Ethiopia, and to Leni Riefenstahl's *Olympia*, about the 1936 Berlin Olympic Games—a film that was technically ineligible, since the festival rules excluded documentaries. Not only was the event a triumph for Fascism; it lured tourists away from the French Riviera's beaches and hotels to those of the Lido de Venezia, the offshore island where Il Duce sited the festival and built a sleekly modern Palazzo del Cinema to house it.

In June 1939, at Erlanger's urging, France announced a similar festival, to take place in Cannes from September 1 through 20. With no time to construct the equivalent of Mussolini's temple to the seventh art, screenings took place in Cannes' ornate *belle epoque* municipal casino. Pioneer Louis Lumière was president—an appropriate choice, since he and his brother Auguste shot their earliest films, including the historic 1895 *L'Arrivée d'un train en gare,* at La Ciotat, near Marseille.

Almost immediately, the festival struck trouble. With notably poor timing, it opened on the day Hitler invaded Poland. The singer/comic Fernandel, hired to lead the open-air gala launch, fled with the other guests as a rainstorm swept the beach. Once news of Poland arrived, the festival closed hurriedly after screening only one film, *The Hunchback of Notre Dame*, starring Charles Laughton. Guest stars

Tyrone Power, Mae West, Gary Cooper and George Raft returned to Hollywood, having wasted their visit.

No further festivals took place until 1946, when the event was revived in hopes of coaxing tourists back to a postwar *côte* much less *azur*. From the start, Cannes suffered from an ambivalence about its function. Jean-Gabriel Domergue's poster for the 1939 event, featuring a man in evening dress and a slim, tanned beauty in a backless evening gown, signaled that the festival was aimed at tourists. However, producers who sent films in hopes of finding a distributor urged a more businesslike atmosphere. The festival would struggle until it decided whether it was a cultural celebration or trade fair.

A clash over clothing typified these teething problems. The casino expected audiences to wear evening dress, or at least a suit and tie. When the habitually casual cinema community protested, screenings were divided into those that did or did not require formal dress. This brought immediate accusations that films included in the "tie-less" programs were somehow inferior.

Struggling with postwar debt and a growing Communist presence, France had little time for the arts and even less for film festivals. Moreover, the country was awash with movies as a backlog of American and British films, unseen during the Nazi occupation, flooded the market. Throughout Cannes' first years, it screened whatever films

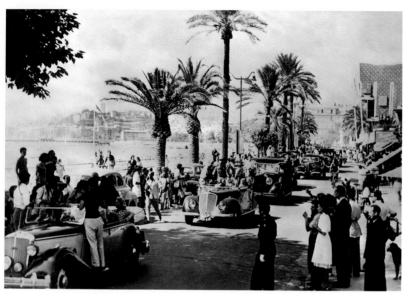

Cannes Film Festival, 1947

producers cared to send, while juries consisted
mainly of bureaucrats and academics, chosen less
for cinematic expertise than political correctness.
Bias prevailed. Of forty-four competing films in
1946, the United States contributed seven, yet
the eighteen-person jury included only a single
American, British-born Iris Barry, head of the
Museum of Modern Art's film division and a lifelong
enemy of Hollywood. Out of eleven grand prizes,
only one went to an American film—Billy Wilder's
stark depiction of alcoholism, *The Lost Weekend*. In
1947, an all-French, all-male Cannes jury conferred
just a handful of awards. In 1948 no festival took
place at all.

The corner was turned when organizers decided to stop competing with Venice and moved the Cannes event to May. They also demolished the old casino and erected an aggressively modern Palais des Festivals. After a false start in 1949 when the roof of the new building blew off, Cannes was reborn in 1951 in more or less its present form.

The conflict between art and commerce was resolved by accommodating both. A market of films shown out of competition served filmmakers seeking a distributor. At the same time, around twenty "official selections" competed for the Palme d'Or, a golden frond inspired by the Riviera's semi-tropical vegetation. When American producers complained of being fobbed off with minor distinctions, the festival introduced special jury prizes, a Critics' Award and an ever-lengthening menu of honors that ensured few went home empty-handed.

Moving the festival to May transformed the event. Producers were more eager to enter their films, since a prize could improve the chances of commercial success during the summer. As the first festival of the season, Cannes also got the pick of new productions. Hollywood entered more and better films, and sent stars to promote them, while a seat on the streamlined jury, trimmed down to eight members, became less a chore than an honor, though in one case at least an honor misplaced. In 1980, instead of the first choice for jury president, Douglas Sirk, the veteran director of *Written on the Wind* and *All That Heaven Allows*, actor Kirk Douglas was invited by mistake.

Cannes made world headlines in 1954, not for any artistic reasons but because an unknown French/ Egyptian B-movie actress, Simone Silva, wearing only a short skirt and a bra, posed on the beach with actor Robert Mitchum. Egged on by photographers, she dropped her top, inaugurating a tradition of semi-nude displays at Cannes that did more to put the festival on the map than any celebration of cinematic excellence.

The previous year, director Roger Vadim used the festival to present his wife Brigitte Bardot, even though she had made only a few films, and would not achieve stardom until *Et Dieu... Créa la Femme— And God Created Woman,* which he was about to shoot in St. Tropez. Indifferent to the fact that she wasn't promoting anything but herself and her mentor, the press photographers ate her up. She had become one of the first synthetic celebrities— famous simply for being famous.

Recognizing their growing value to filmmakers, photojournalists became increasingly demanding. In 1975, after actor Paul Newman refused to pose for pictures, they lowered their cameras as he arrived for the opening night of *Cat on a Hot Tin Roof,* leaving him to mount the red carpeted staircase without the flashes that signified free publicity. Thereafter more obliging, Newman called the incident "the most valuable lesson I ever learned."

As Cannes gained stature, juries too began to realize their power, and to exercise it. In 1954, Luis Buñuel protested as other members bowed to Hollywood

From left: Simone Silva posing topless with Robert Mitchum at 1954 Cannes festival; Grace Kelly at the Festival in 1955 when she met Prince Rainier III of Monaco for the first time

pressure and selected the World War II melodrama *From Here to Eternity* for the Palme d'Or instead of the Japanese film *Gate of Hell*. He also refused to vote for a compromise winner, René Clément's lightweight romance *Monsieur Ripois*. When, at the closing ceremony, *Gate of Hell* received the grand prize, Clément's film a jury special prize and *From Here to Eternity* a special award, Buñuel stormed out of the theater and threw his unaccustomed dinner jacket into the sea.

In 1960, the jury president, crime novelist Georges Simenon, proved no less intransigent. After denying festival director Robert Favre Le Bret his customary courtesy seat at jury meetings, Simenon decided Federico Fellini's *La Dolce Vita* was superior to the favorite, Michelangelo Antonioni's *L'Avventura*. By

securing the proxies of other members, including fellow novelist Henry Miller, who preferred playing table tennis to watching films, Simenon ensured Fellini the Palme d'Or.

Having played politics for so long, the festival should not have been surprised to find itself the center of a political storm in 1968, when students and intellectuals, angered by the firing of charismatic but erratic Henri Langlois as head of the Cinémathèque Française, used Cannes to attack the stodgy cultural policies of Charles de Gaulle. Young directors, in particular François Truffaut, Jean-Luc Godard and Claude Lelouch, disrupted the opening night, clinging to the curtain of the main auditorium and forcing the festival to shut down entirely.

The following year saw changes, including a student on the jury, and the inauguration of the Directors' Fortnight, a noncompetitive program of new films selected by the French Directors' Guild. From 1972, in a belated declaration of independence, the festival also insisted on choosing the films it showed rather than automatically accepting those entered by individual countries. In 1978, festival director Gilles Jacob introduced *Un Certain Regard*, a program showcasing independent or innovative films, often from first-time directors.

Paradoxically, the events of 1968, intended to make the festival more democratic, had the opposite effect. Cannes in May became a place to be seen, whether one was interested in films or not. The best hotels were booked months in advance. As yachts

Cannes Festival, 2008

filled the marinas, Maseratis and Ferraris were
flown in from the Persian Gulf and parked along the
beachfront, ostentatiously announcing the presence
of some sheik or prince. In the hills, once obscure
restaurants such as the Moulin de Mougins and the
Colombe d'Or welcomed free-spending celebrities,
and adjusted their prices accordingly. At the
outdoor interview suites of the world's TV channels,
celebrities plugged their latest film against the
background of Europe's most expensive visual
wallpaper. Among international events, only the
Olympics attracted a larger contingent of press.

Competition for tickets was intense, the pecking
order ruthlessly enforced, even though celebrities,
after posing for the press on the crimson carpet at

VINTAGE POSTCARDS CANNES

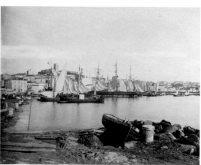

25 - CANNES...La Plage et la Croisette.

the foot of the wide steps leading up to the 2,246-seat Grand Auditorium Louis Lumière, seldom bothered to see any films but their own. Genuine *cinéastes* were barred while scores of seats remained empty, the celebs too busy partying to attend. At the 1946 Festival, Roberto Rossellini, director of *Rome, Open City*, complained that he and his brother were almost the only people awake at the afternoon screening, everyone else was sleeping off their lunch. That too became a well-established tradition.

In the half-century following 1968, the Cannes Film Festival asserted itself not only as a showbusiness event but also a social and cultural phenomenon. To signify its supra-cinematic significance, it abandoned all reference to films and called itself simply the Festival de Cannes.

Like the Academy Awards, Cannes epitomized the glitz and fantasy that kept audiences returning to the cinema. "The worst of Cannes has been the best of Cannes," argued American critic Andrew Sarris, usually a spokesman for the intellectual elite. "If it were less a zoo and more an art gallery, it would be paradoxically less interesting, even to people whose primary interest is ostensibly in the art of the film."

Epilogue

Though Simone Silva's topless stunt made her briefly notorious, it failed to reignite her declining career. Deported to England after the festival, she died in 1957, aged only 29, a victim of crash dieting.

Parodying the ever-lengthening list of prizes presented at Cannes, special interest groups would later introduce a Queer Palm for excellence in gay cinema and a Palme d'Og honoring canine performances.

French Riviera and Its Artists

ART GALLERY OF
THE CÔTE D'AZUR

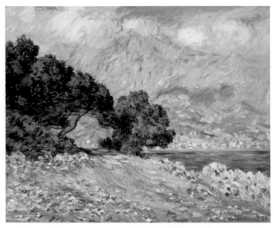

Menton

From top: *Cap Martin, Near Menton,* Claude Monet, 1884, Museum of Fine Arts Boston: *Menton,* Émile Appay, c. 1910-1920, Private Collection; *Harbor of Menton,* Albert Marquet, 1905, The State Hermitage Museum, Saint Petersburg

Monte Carlo

From top: *Monte Carlo Seen From Roquebrune*, Claude Monet, 1884, Private Collection; *The Casino, Monte Carlo*, Christian Ludwig Bokelman, 1884, Private Collection; *At the Roulette Table in Monte Carlo*, Edvard Munch, 1892, Munch Museum, Oslo

Cap d'Ail

Nice

From top: *The Garden at Cap d' Ail*, Sir John Lavery, 1921, Private Collection; *Le Port de Nice*, Berthe Morisot, 1882, Musee Marmottan Monet, Paris

From top left: *Under the Palm Trees in Nice*, Edvard Munch, 1891, Private Collection; *The Bay of Nice*, Henri Matisse, 1918, Private Collection; *Promenade des Anglais, Nice*, Edvard Munch, 1891, Private Collection

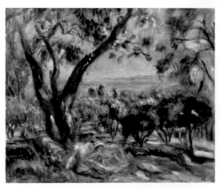

From top: *The Cypresses at Cagnes*, Henri-Edmond Cross, 1908, Musée d'Orsay; *Terrace in Cagnes*, Pierre-Auguste Renoir, 1905, Bridgestone Museum of Art, Tokyo; *Cagnes Landscape with Woman and Child*, Pierre-Auguste Renoir, 1910, Private Collection

Saint Paul
de Vence

Grasse

From top: *Vista de Saint Paul de Vence*, André Derain, 1910, Museum Ludwig, Cologne; *La Fontaine, Saint Paul de Vence,* Henri Le Sidaner, 1925, Private Collection; *Village Scene, Grasse*, Pierre Bonnard, 1912, The Metropolitan Museum of Art

Antibes

From top: *Antibes vue du Plateau de Notre Dame*, Claude Monet, 1888, Museum of Fine Arts Boston; *Coast Near Antibes*, Henri-Edmond Cross, 1891, Private Collection; *Antibes, Thunderstorms*, Paul Signac, 1919, Albertina, Vienna

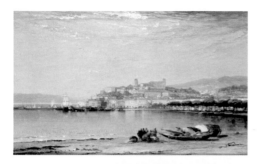

From top: *Cannes*, Arthur Joseph Meadows, 1897, Towneley Hall Art Gallery & Museum; *The Artist's Wife and Emilie von Etter Balcony in Cannes*, Albert Edelfelt, 1891, Finlands Nationalgalleri; *Vieux port de Cannes*, Paul Signac, 1918, Private Collection

Saint-Tropez

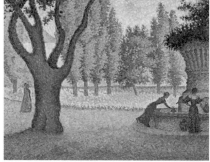

Hyeres

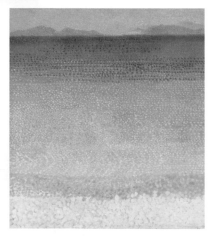

From top: *View of St. Tropez*, Henri Matisse, 1901, Private Collection; *Saint-Tropez Fontaine Des Lices*, Paul Signac, 1895, Private Collection; *Les Iles d'Or (The Iles d'Hyeres, Var)*, Henri-Edmond Cross, 1891-1892, Musée d'Orsay

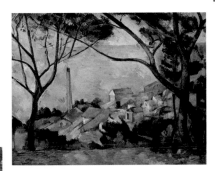

L'Estaque

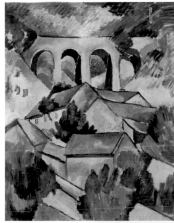

From top: *The Sea at L'Estaque*, Paul Cézanne, 1879, Musée Picasso; *The Viaduct at L'Estaque*, Georges Braque, 1908, Musée National d'Art Moderne, Centre Georges Pompidou, Paris; *The Turning Road, L'Estaque*, André Derain, 1906, The Museum of Fine Arts, Houston

French Riviera and Its Artists
LIST OF SITES

Town	Site	Related	Chapter	Year
Menton				
	Villa Isola Bella	Katherine Mansfield	4	
	Villa Grimaldi	Serge Voronoff	4	
	The Salle des Mariages	Jean Cocteau	14	
	Bastion Museum	Jean Cocteau	14	
Roquebrune-Cap-Martin				
	Hôtel Idéal Séjour	William Butler Yeats	4	
	La Pausa	Coco Chanel	7	1929-1953
Monaco				
	Café de Paris	Serge Diaghilev	8	1910-1929
	Monte Carlo Casino	Gobineau de la Bretonnerie	18, 19	1863
	Hôtel de Paris	Gobineau de la Bretonnerie	18	1864
	Salle Garnier	Charles Garnier	18	1879
	Oceanographic Museum	Prince Albert I	18	1910
St. Jean-Cap-Ferrat				
	Villa Santo-Sospir	Jean Cocteau	14	1950-1963
	Villa Mauresque	William Somerset Maugham	14	1926-1965
Villefranche-sur-Mer				
	Villa La Leopolda	*The Red Shoes* film location	8	
	Chapel of Saint Peter	Cocteau's mural	14	1957
Nice				
	Hôtel Beau Rivage	Henri Matisse	3	
	105 Quai des États-Unis	Henri Matisse	3	
	1 Place Charles Félix	Henri Matisse	3	1921-1938
	The Regina	Henri Matisse	3	1938-1954
	Monastère Notre Dame de Cimiez	Henri Matisse	3	1954-
	The Musée Matisse	Henri Matisse	3	1963-
	Musée National Marc Chagall	Marc Chagall	15	1973-
	Frank Harris's home at 9 rue de la Buffa	Frank Harris	5	1928-1931
	The Victorine Studios (Studio Riviera)	Alice Terry and Rex Ingram	20	1921-
Cagnes-sur-Mer				
	Les Collettes	Pierre-Auguste Renoir	2	1908-1919
St Paul de Vence				
	La Colline	Marc Chagall	15	
	Foundation Maeght	Aimé and Marguerite Maeght	15	
Vence				
	Le Rêve	Henri Matisse	3	1943-1949
	Chapelle du Rosaire	Henri Matisse	3	1951
	Vence Cathedral	Marc Chagall	15	1979

Antibes			
Château Grimaldi (Musée Picasso)	Pablo Picasso	13	1946
Hôtel du Cap	Murphys and others	9	1889-
Royal Hotel	Graham Greene	17	1960
Résidence des Fleurs	Graham Greene	17	
Chez Felix	Graham Greene	17	

Vallauris			
Peace Chapel (National Picasso Museum)	Pablo Picasso	13	
Villa La Galloise	Pablo Picasso	13	1948-1955

Le Cannet			
Le Bosquet	Pierre Bonnard	11	1926-1947

Cannes			
Villa La Californie (Pavillon de Flore)	Pablo Picasso	13	1955-1961
Carlton Hotel		19	2013
Palais des Festivals		21	1951-

Mougins			
Mas de Notre-Dame du Vie	Pablo Picasso	13	1962-1973

Grasse			
Charles de Noailles' gardens	Charles and Marie-Laure de Noailles	10	

Fréjus			
Chapel of Notre Dame de Jerusalem	Jean Cocteau	14	1960-

Saint Tropez			
La Madrague	Brigitte Bardot	16	1958-
La Garrigue	Brigitte Bardot	16	
Byblos	Jackie Onassis, Mick Jagger	16	
Pampelonne Beach	Princess Diana, Dodi Fayed	16	
The Musée de l'Annonciade	Paul Signac, André Derain	16	

Hyères			
Chalet de Solitude	Robert Louis Stevenson	4	
Villa Noailles	Charles and Marie-Laure de Noailles	10	1925-
Castel Sainte-Claire	Edith Wharton	12	1927-

Sanary-sur-Mer			
Villa Huxley	Aldous Huxley	12	

Bandol			
Hôtel Beau Rivage	Katherine Mansfield, D. H. Lawrence	4	

L'Estaque			
The House on the Place Malterre	Paul Cézanne	1	

Vauvenargues			
Château de Vauvenargues	Pablo Picasso	13	1958-

INDEX

ABOUT MUSEYON

Named after the Museion, the ancient Egyptian institute dedicated to the muses, Museyon Guides is an independent publisher that explores the world through the lens of cultural obsessions. Intended for frequent fliers and armchair travelers alike, our books are expert-curated and carefully researched, offering rich visuals, practical tips and quality information.

CREDITS

MUSEYON'S OTHER TITLES

For more information visit **www.museyon.com**, facebook.com/museyon or twitter.com/museyon

Publisher: Akira Chiba

Editor: Janice Battiste

Assistant Editor: Mackenzie Allison

Cover Design: José Antonio Contreras

Map Design: Shino Okawara

SN Marketing: Sara Marquez

Museyon Guides has made every effort to verify that all information included in this guide is accurate and current as of our press date. All details are subject to change.

ABOUT THE AUTHOR

 John Baxter is an Australian-born writer, journalist and filmmaker; he has called Paris home since 1989. He is the author of numerous books including the autobiographical *Immoveable Feast: A Paris Christmas, The Most Beautiful Walk in the World: A Pedestrian in Paris, Chronicles of Old Paris: Exploring The Historic City of Light* and *The Golden Moments of Paris: A Guide to the Paris of the 1920s*.